For my parents

First published in 1992 by
The Bodley Head Children's Books
an imprint of The Random Century Group Ltd
20 Vauxhall Bridge Road, London SW1V 2SA

Random Century Australia Pty Ltd
20 Alfred Street, Sydney, NSW 2061

Random Century New Zealand Ltd
PO Box 40-086, Glenfield, Auckland 10, New Zealand

Random Century South Africa Pty Ltd
PO Box 337, Bergvlei 2012, South Africa

Printed in Singapore by
Tien Wah Press (Pte) Ltd

A catalogue record of this book is available from the British Library
ISBN 0 370 31 740 8

Ophir

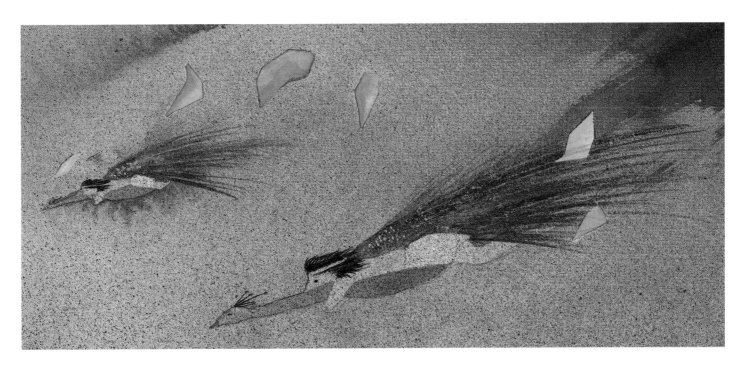

Smadar Samson

The Bodley Head
London

I once met a boy called Ophir. 'Tell me,' I said, 'where does your name come from?'

Ophir looked out to sea. He had been told the story so many times that he knew it off by heart.

'Well,' he began: 'Many years ago there was a magical place far from here; no one knows exactly where ...

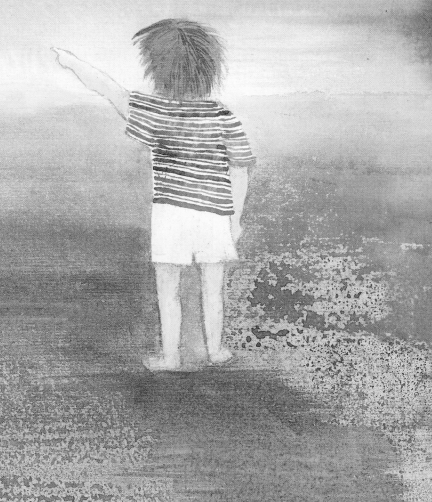

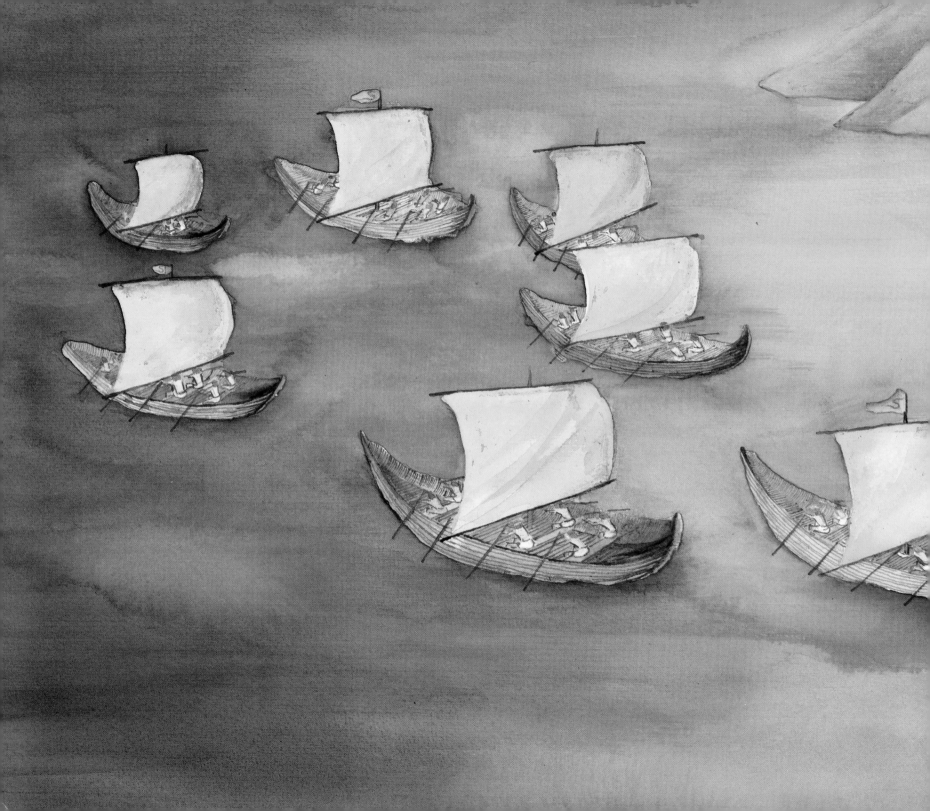

'It all happened long, long ago, at the time of King Solomon. The king's fleet had been sailing the oceans in search of treasure. Months had passed, but the sailors had seen nothing but barren mountains and the still, red sea. It seemed that their journey was endless, and they had all but given up hope.

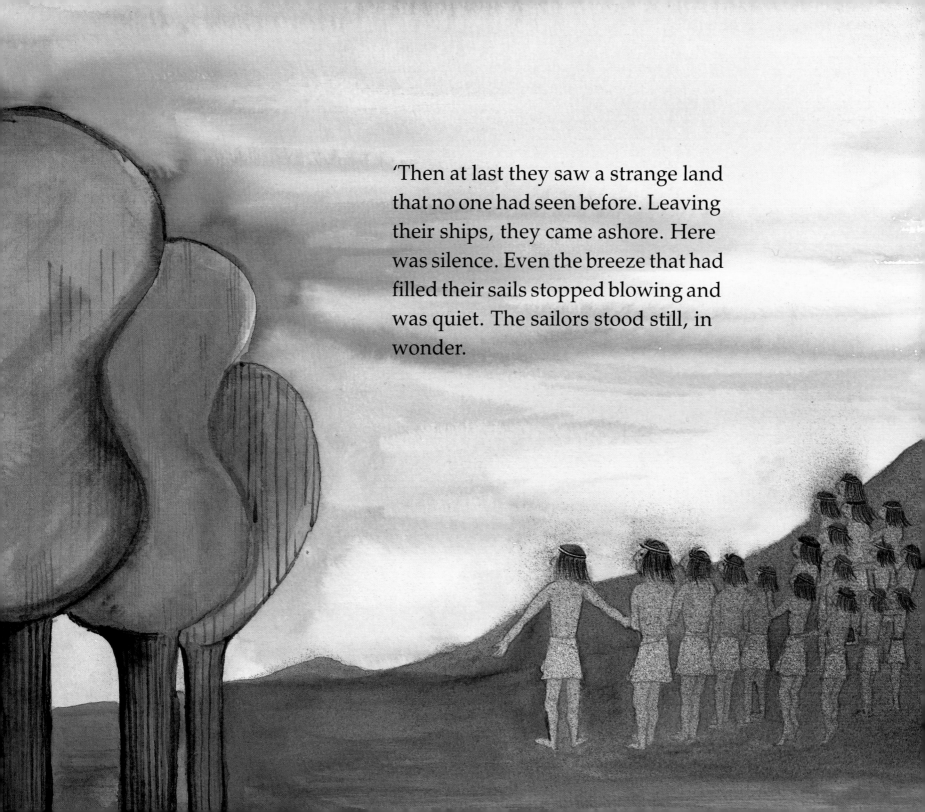

'Then at last they saw a strange land that no one had seen before. Leaving their ships, they came ashore. Here was silence. Even the breeze that had filled their sails stopped blowing and was quiet. The sailors stood still, in wonder.

'As if touched by an invisible wand, the trees began to sing. Sweet music filled the air and slowly, from all corners of the land, the animals and birds gathered to listen.

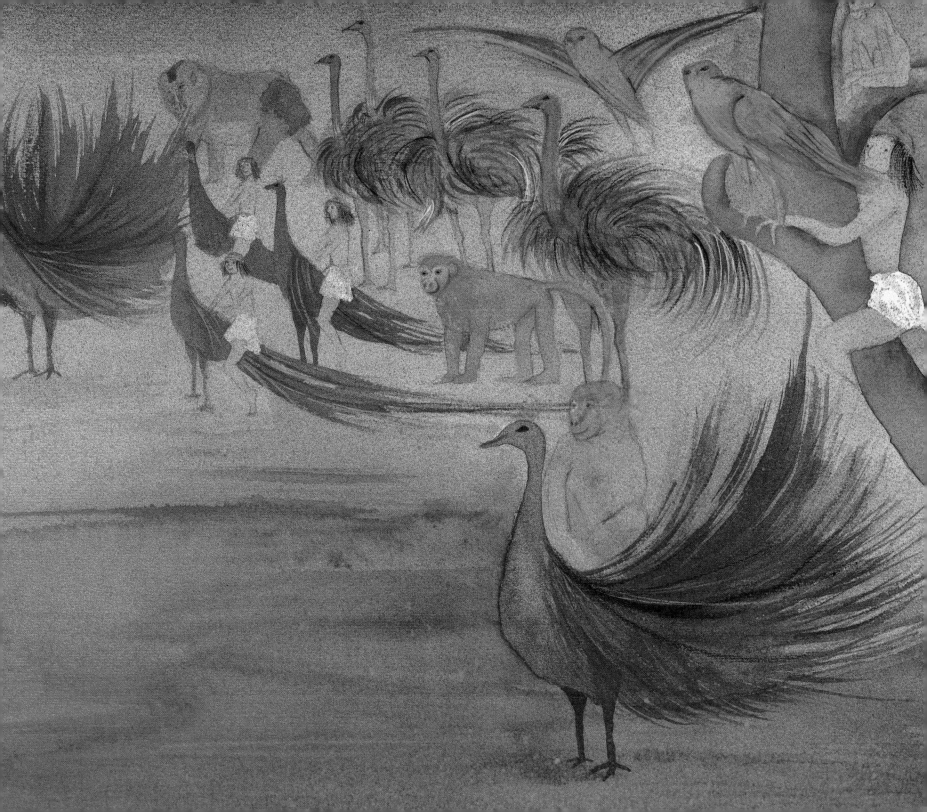

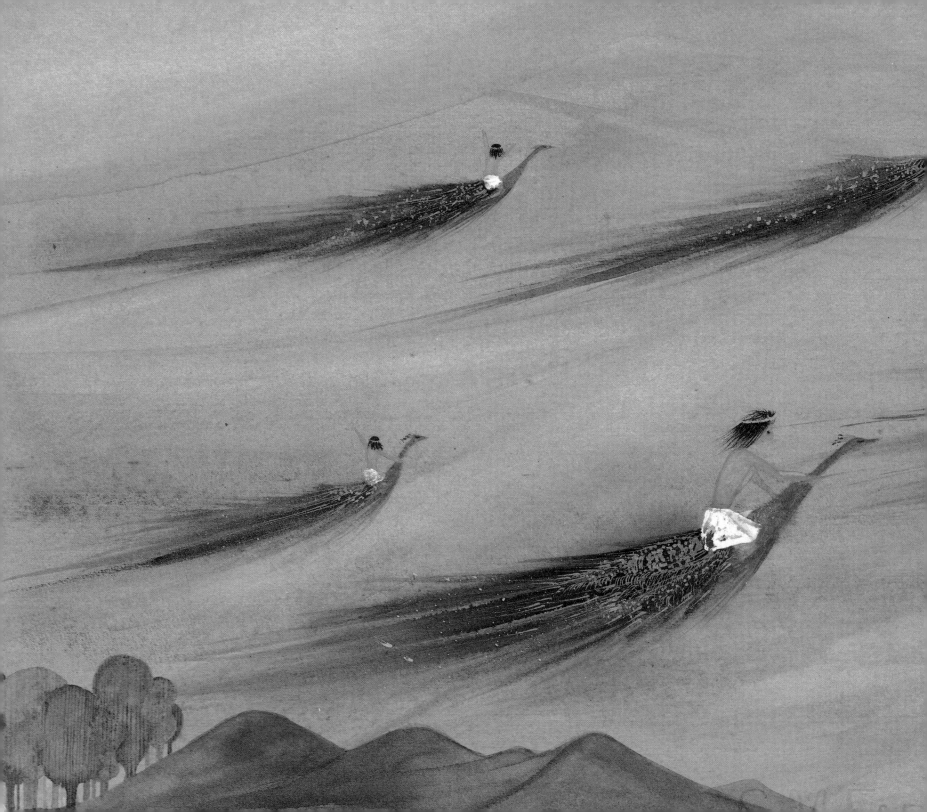

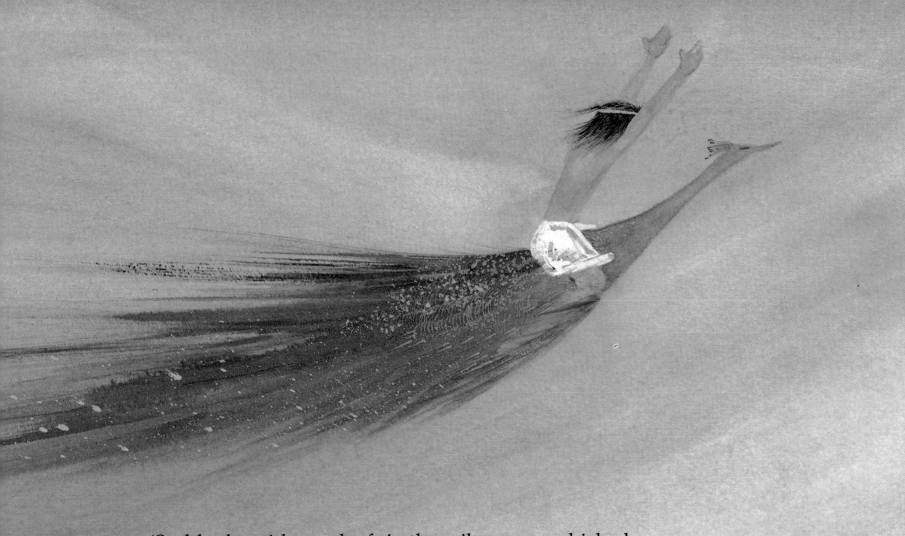

'Suddenly, with a rush of air, the sailors were whisked up on beating wings, off into the crisp blue sky and far beyond the dark mountains. Flying high above the clouds, they laughed and called out to each other. They didn't even hear the loud rumbling thunder which shook the skies and grew ever nearer.

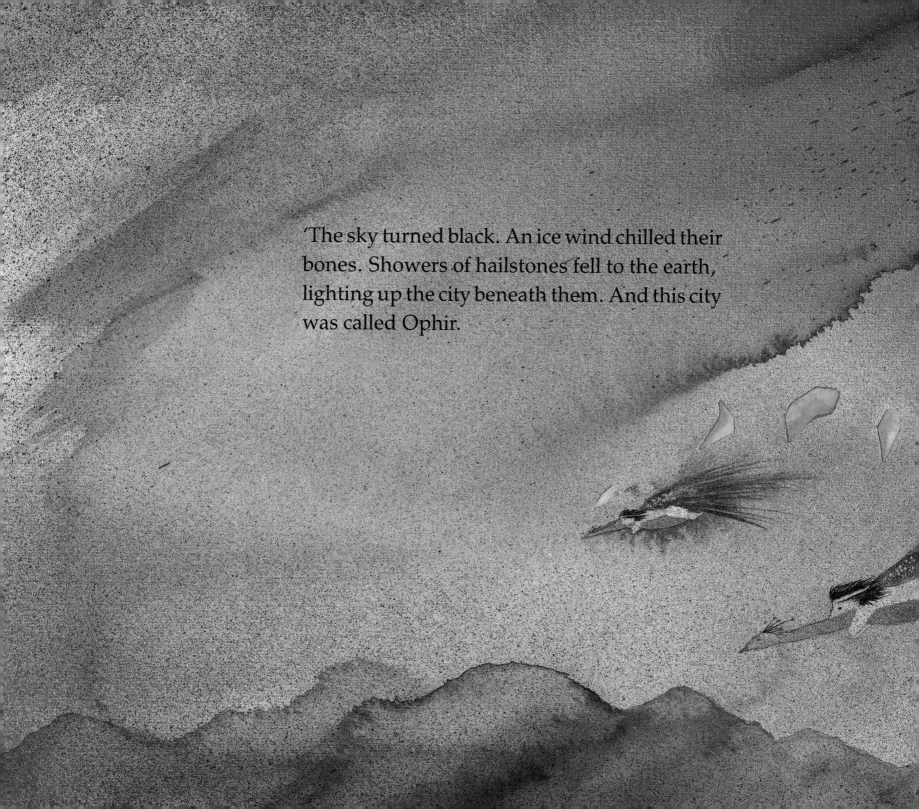

'The sky turned black. An ice wind chilled their bones. Showers of hailstones fell to the earth, lighting up the city beneath them. And this city was called Ophir.

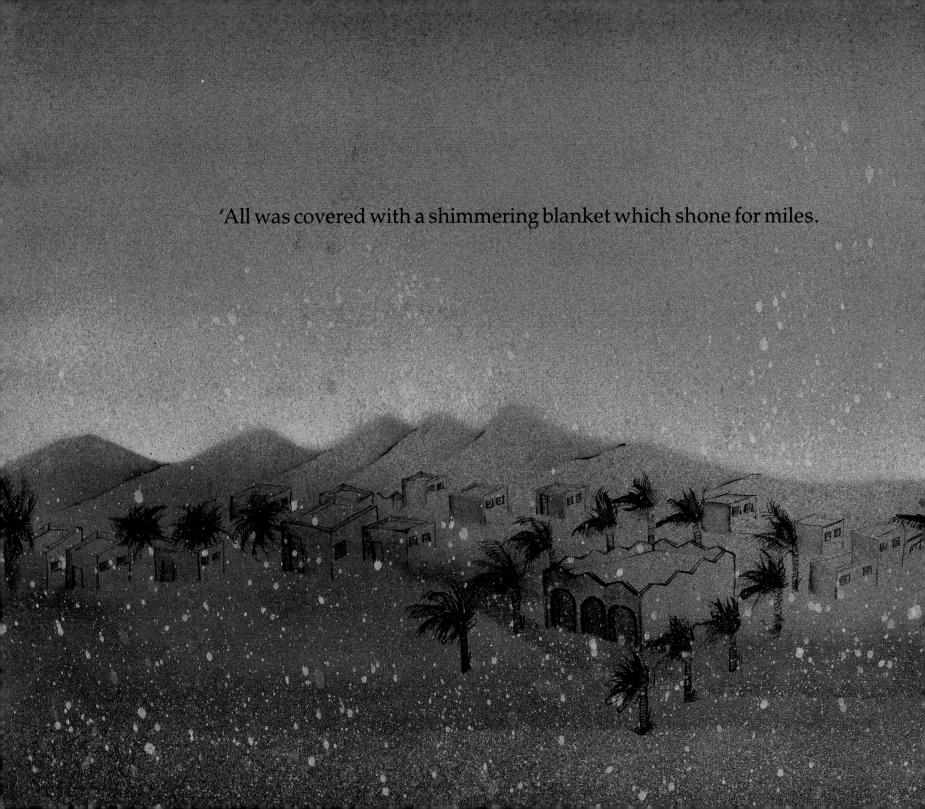

'All was covered with a shimmering blanket which shone for miles.

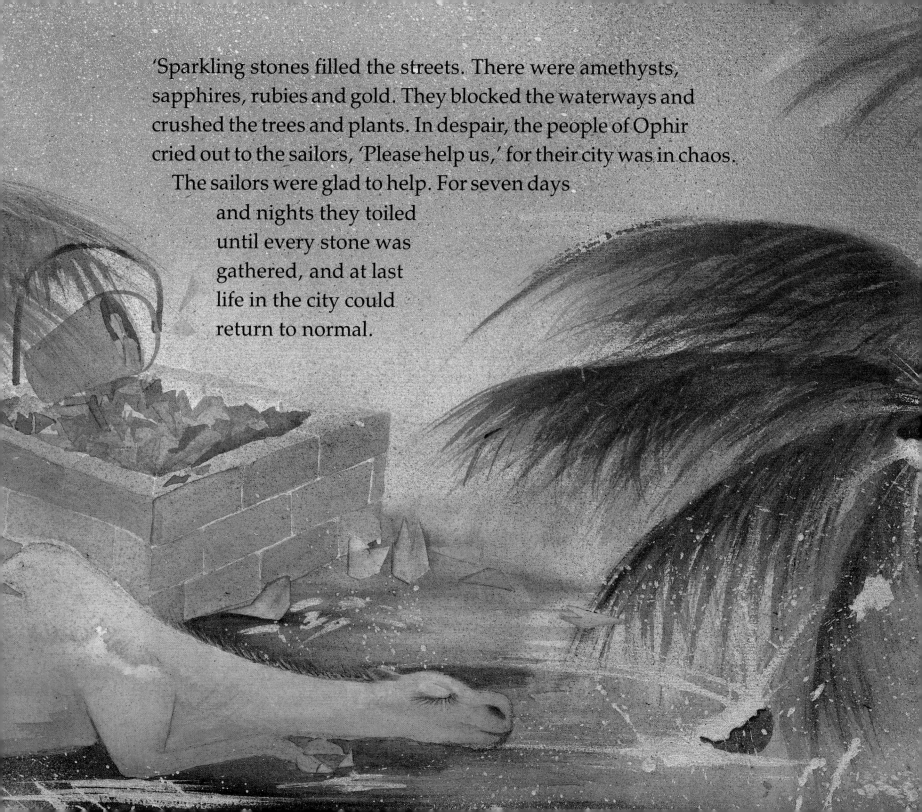

'Sparkling stones filled the streets. There were amethysts, sapphires, rubies and gold. They blocked the waterways and crushed the trees and plants. In despair, the people of Ophir cried out to the sailors, 'Please help us,' for their city was in chaos.
 The sailors were glad to help. For seven days and nights they toiled until every stone was gathered, and at last life in the city could return to normal.

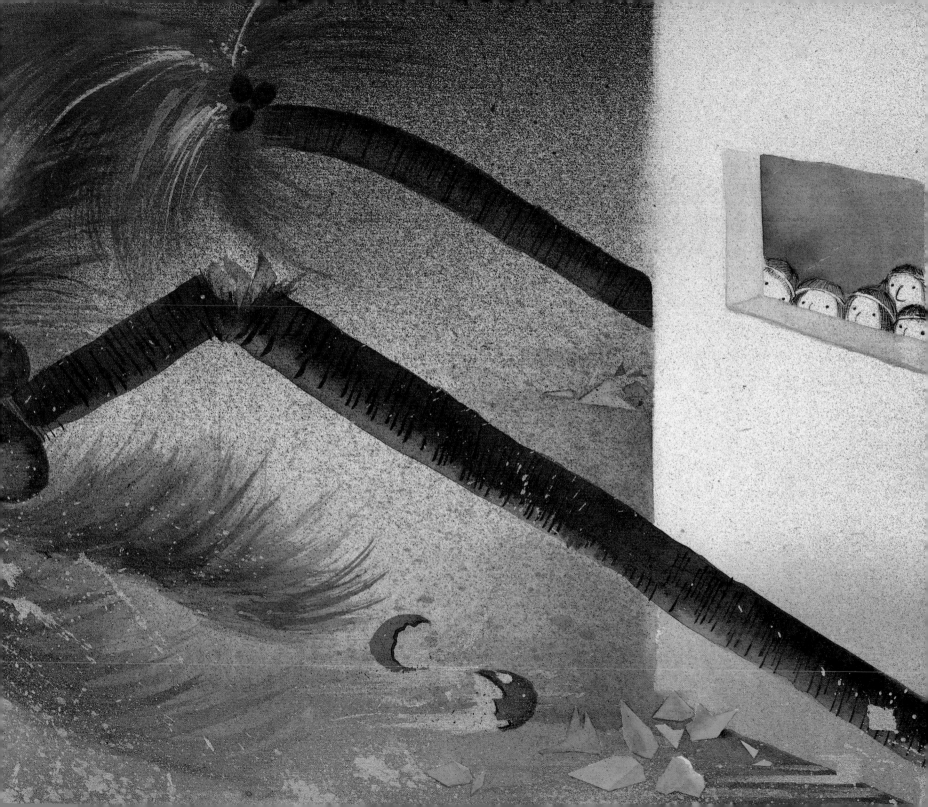

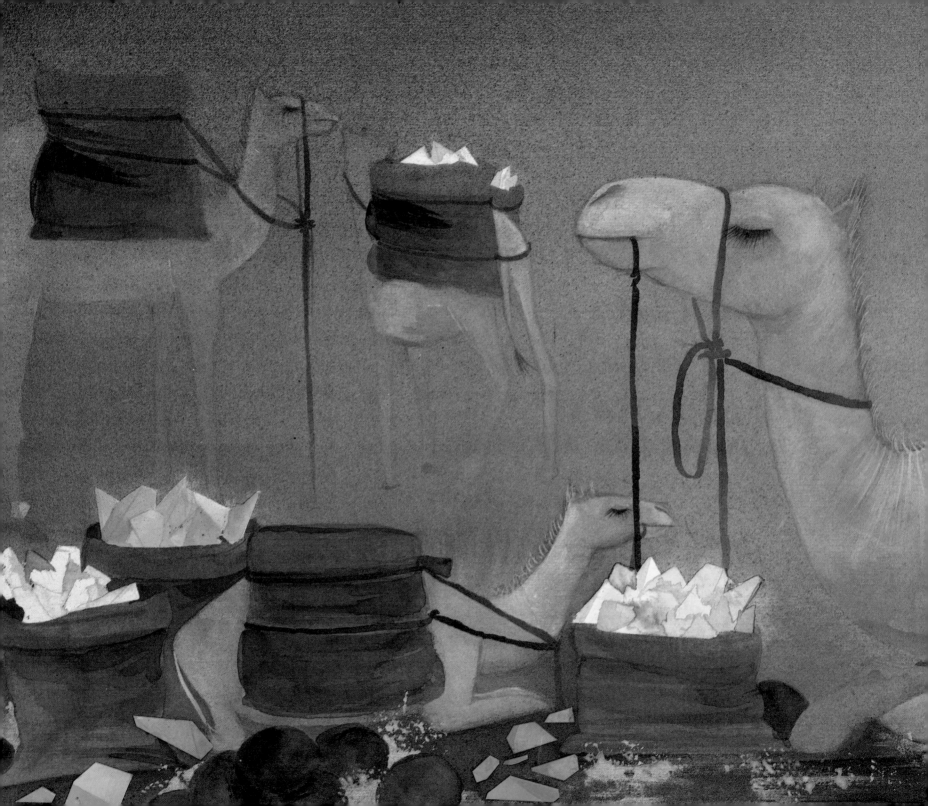

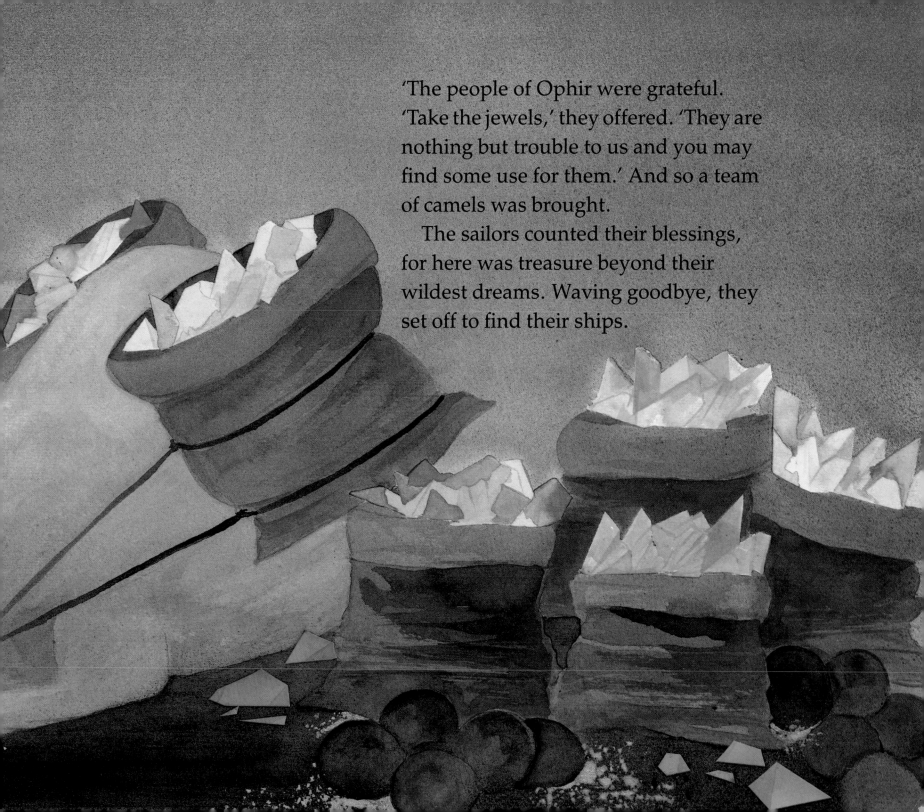

'The people of Ophir were grateful. 'Take the jewels,' they offered. 'They are nothing but trouble to us and you may find some use for them.' And so a team of camels was brought.

The sailors counted their blessings, for here was treasure beyond their wildest dreams. Waving goodbye, they set off to find their ships.

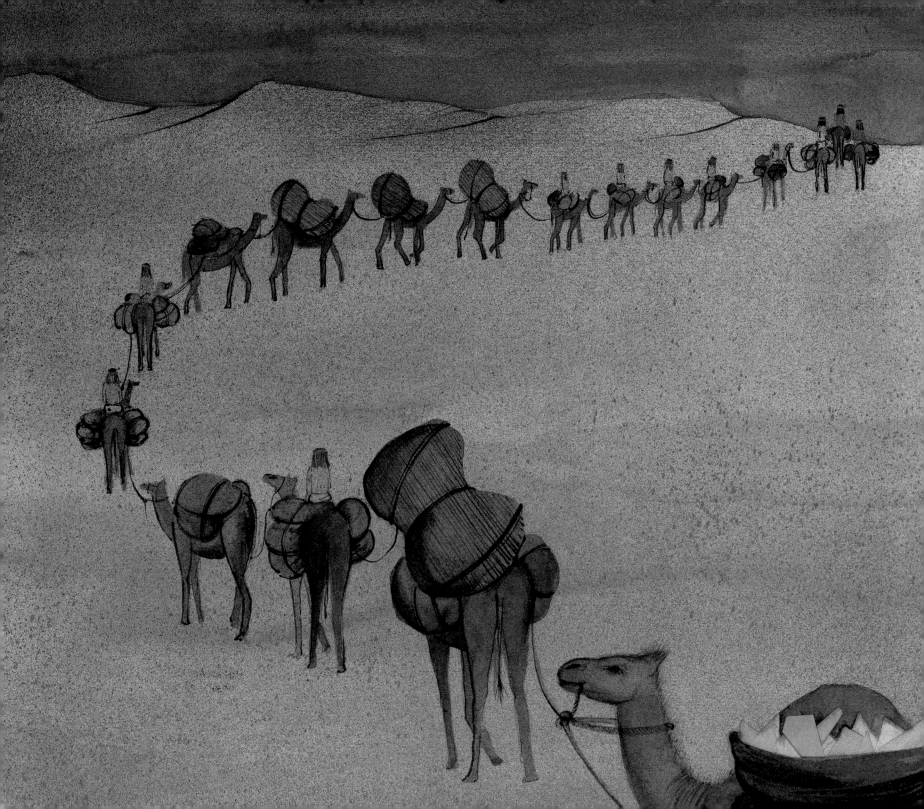

'The trek was long and hard, through miles of blinding sandstorms and endless dunes. Often they imagined they could see their fleet in the distance. Finally, there it was. And so the sailors embarked on their long journey home.

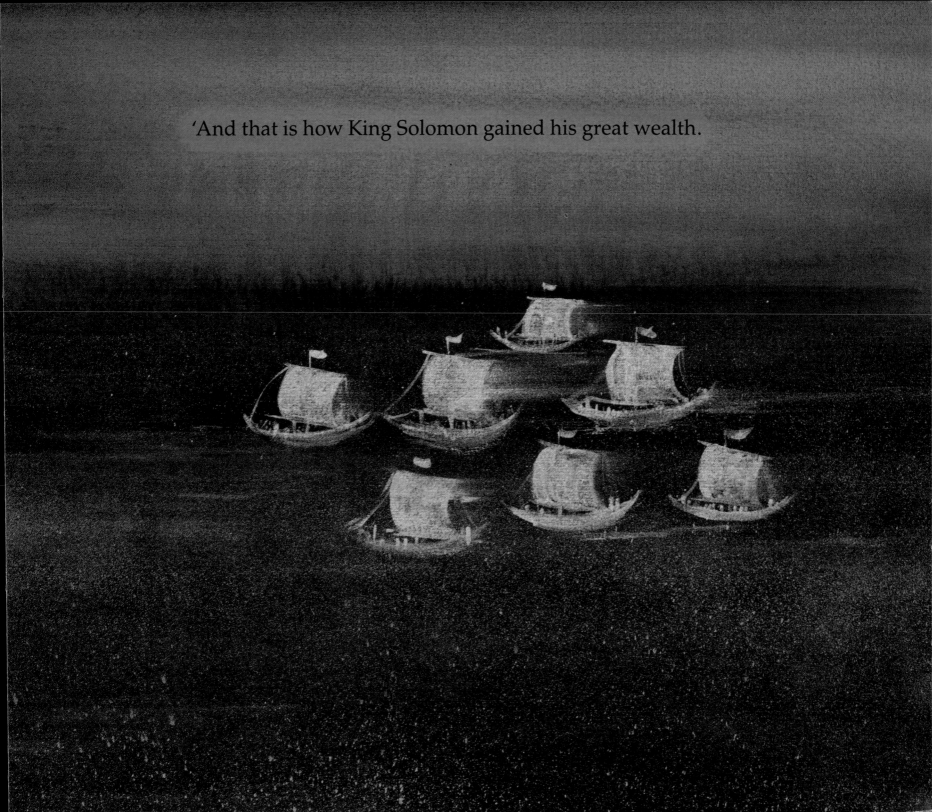

'And that is how King Solomon gained his great wealth.

'In the years that followed, many people tried to find the lost city of Ophir, kings, priests, merchants, pirates and even prophets. But no one ever did, for their ships were always wrecked.

'That's how the story goes,' Ophir ended.

'You must be proud,' I said. 'Those first brave sailors brought back far more than gold and treasure; they brought you a name.'

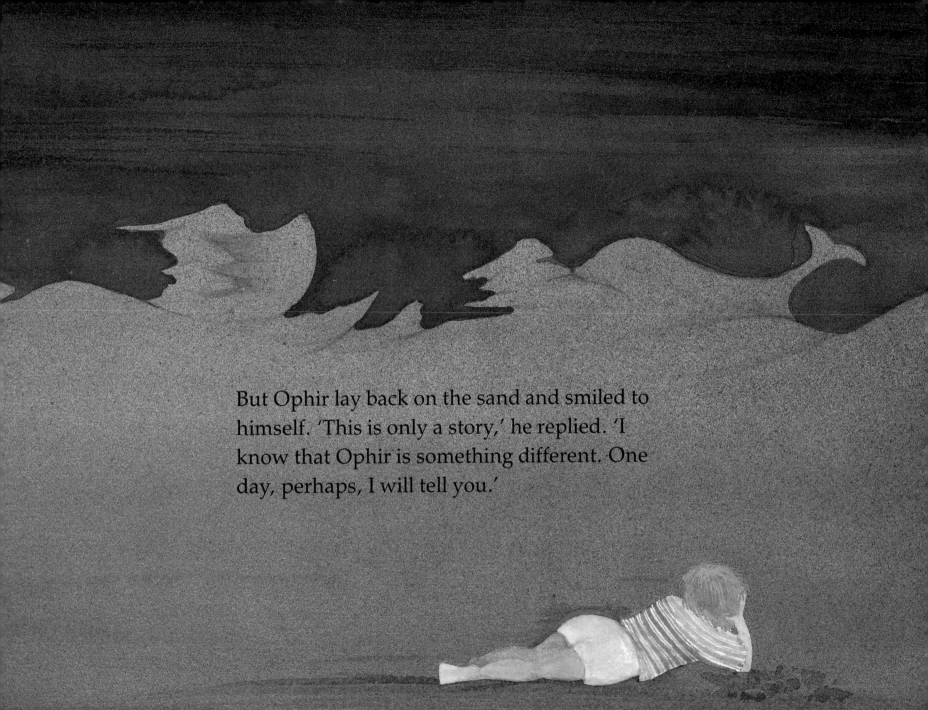

But Ophir lay back on the sand and smiled to himself. 'This is only a story,' he replied. 'I know that Ophir is something different. One day, perhaps, I will tell you.'

This stone was found in Tell Qasile (near Tel Aviv) in 1946, with the following inscription:

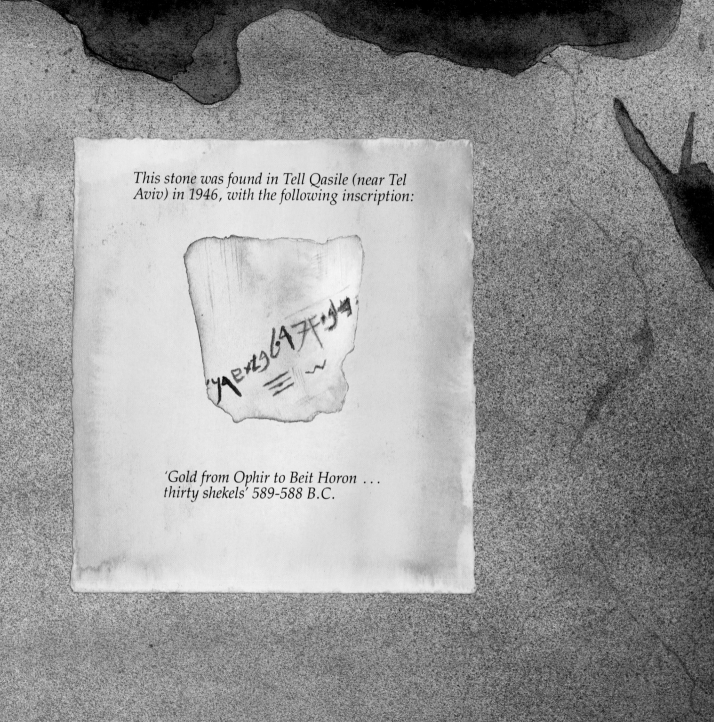

'Gold from Ophir to Beit Horon . . . thirty shekels' 589-588 B.C.

c002

COPY 17

701.18 Taubes, Frederic, 1900-
T A judgement of art : fact and fiction
 / Frederic Taubes. Westport, Conn. :
 North Light Publishers, [1981]

 143 p. : ill.

 ISBN 0-89134-038-6 : $14.95

 1. Art criticism.

 35063

 81-553 Ja82
 CIP MARC
 MAR - 2 1982
 16

A Judgement of Art
Fact and Fiction

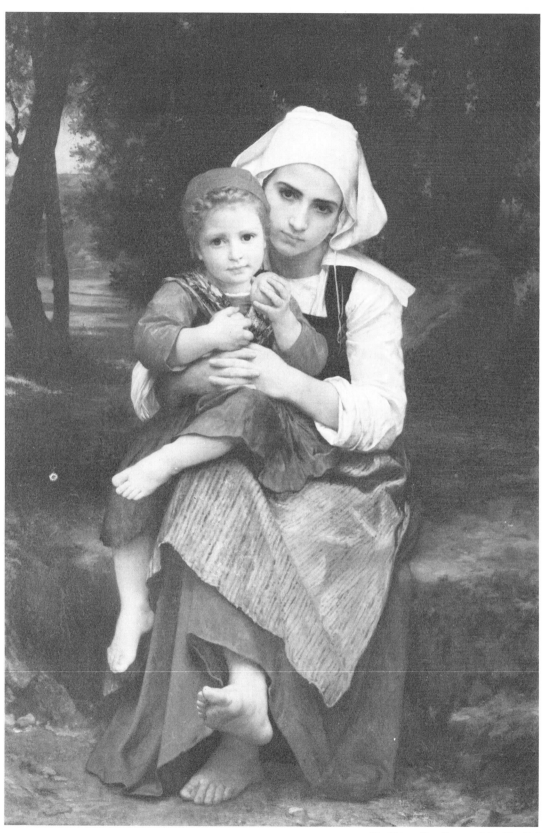

William Adolphe Bouguereau, BRETON BROTHER AND SISTER

Frederic Taubes

A Judgement of Art
Fact and Fiction

North Light

NORTH LIGHT PUBLISHERS
37 Franklin Street, Westport, Connecticut 06881

TO MY WIFE

Published by NORTH LIGHT PUBLISHERS,
a division of FLETCHER ART SERVICES, INC.,
37 Franklin Street, Westport, Conn. 06881

Distributed to the trade by Van Nostrand Reinhold
Company, 135 West 50th Street, New York, New York 10020

Manufactured in U.S.A.
First Printing, 1981

Library of Congress Cataloging in Publication Data

Taubes, Frederic, 1900-
 A judgement of art.

 1. Art criticism. I. Title.
N7475.T38 701'.1'8 81-553
ISBN 0-89134-038-6 AACR2

Edited by Fritz Henning
Designed by David Robbins
Composed in 11/12 Baskerville by Stet/Shields
Printed by The Book Press
Bound by Economy Bookbinding

4

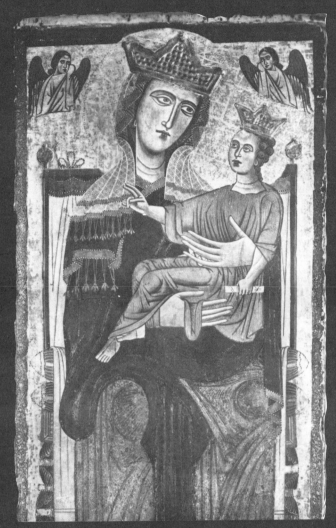

Byzantine Panel, Tuscan, 12th Century

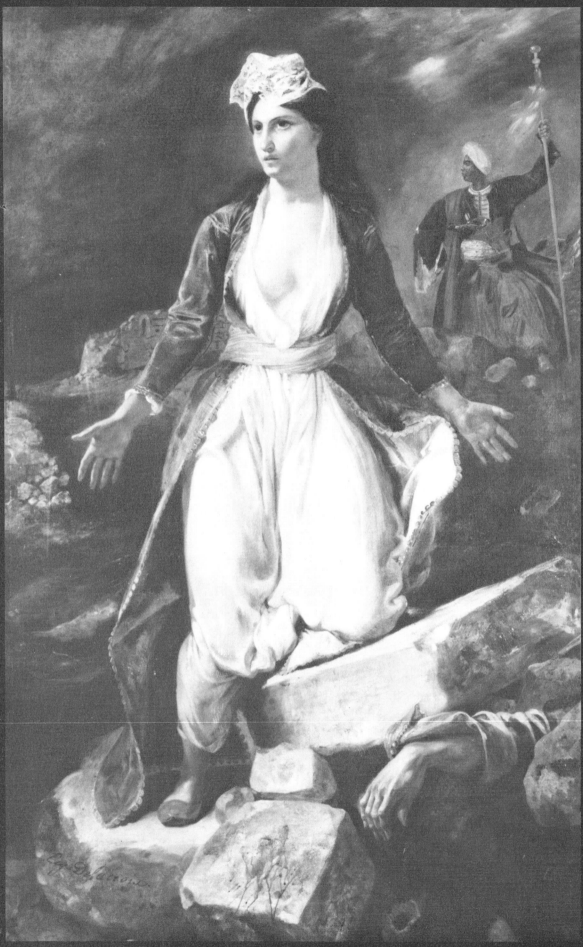

Eugène Delacroix, GREECE EXPIRING ON THE RUINS OF MISSOLONGHI

Contents

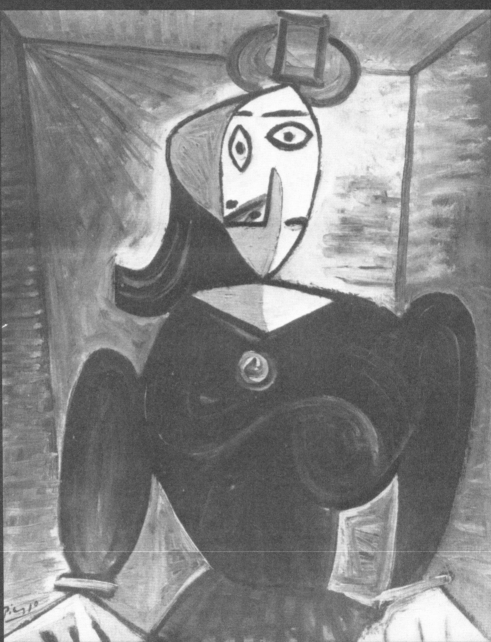

Pablo Picasso, PORTRAIT

List of Illustrations

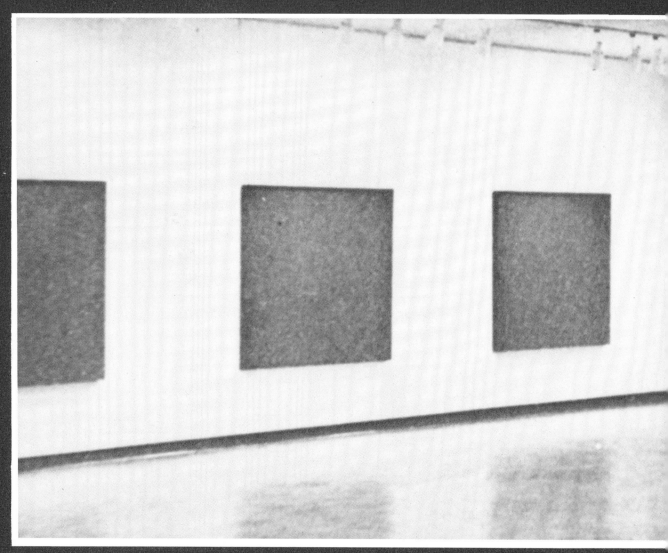

Ad Reinhardt, BLACK PAINTINGS

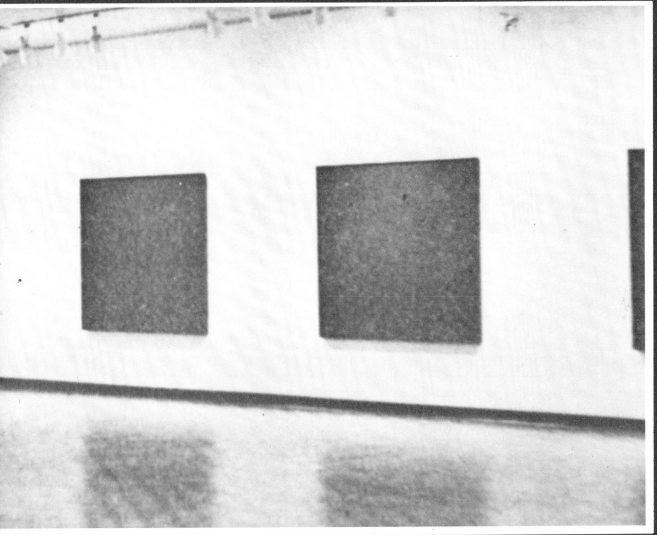

Mark Rothko Chapel, Houston, Texas

Taste and Judgement

Criticism must be oriented to a systematic and historical frame of reference. Criticism is not only evaluation but justification through intelligent description and comparison. The basic criteria of criticism lie in the fundamental aesthetic principles.

— Bernard Berenson

EVEN WITHOUT SPECIAL training, most of us are able to discover and correctly appraise harmonious proportion and balanced position of forms in space. Even the unschooled eye is usually capable of determining that the measurement of a window and its placement in a facade are more or less harmonious, or that the relation of the seat of a chair to its legs has been properly calculated. Moreover, it is obvious at once that the chair is placed in proper relationship with other objects in the room, or that its position is discordant.

In forming judgments on a more abstract level, however, one formidable obstacle that can blur our apperception is individual taste and its corruptive factors. The quality and nature of one's taste is shaped by irrational elements: propensities, proclivities, affinities for this or that conception of art that utterly lack logic.

As a rule, taste for a particular mode is created and inculcated by preceptors, critics and promoters of all shapes and shades who, by occupying a place of "authority," exert undue influence on the public. Hence, when the eyes fail, the intimidated onlooker yields willingly to officially sanctioned judgments. If not conditioned by one's own experience, the human mind becomes automatically programmed by outside forces.

An example of the hallucinations under which people suffer—and this includes the learned connoisseur himself—is the case of Cézanne. (Figure 1). Volumes have been written about his "powerful way with colors," but when you place a Cézanne beside a typical Impressionistic painting, the pallor of Cézanne's "equalized" color is at once apparent. In considering Cézanne's aesthetic system, it must be understood that the "solidity" of his work arises to a large extent from the lack of polychromy.

In addition to having been mesmerized into consent under the corrosive pressure of the taste-makers, the "be in syndrome" exerts a powerful influence on those lacking an inner compass. Why, for instance, does the concert audience, after giving Johann Sebastian Bach his due, applaud with equal, nay greater fervor an atonal abomination appearing on the same program?

If persuasion is a powerful taste-maker, the conventions which arise from this condition can create and perpetuate the greatest folly. People are often incapable of recognizing beauty if it happens to be at odds with familiar standards and current taste. For this reason an El Greco—because the classic element in his art is distorted, or a Negro plastic—because it lacks realistic measurements, was not appreciated for many generations after its creation. Just as our grandfathers reveled in Tschaikovsky and Meissonier, so most of their "advanced" descendants go overboard for Bartok and Picasso. In the development of artistic tastes and standards, it is only natural to become hysterical first in one direction then in the opposite.

In the chaotic conditions which prevail in the evolution of taste, a single civilization will produce widely diverse canons of Beauty. These conceptions of beauty are of local rather than universal significance, and are wont to change according to the particular vogue of the time. Certain nations or cultures develop good taste in specific areas. The French, for example, have good taste in the matter of color. It is unusual to find bad color patterns in French paintings. Is this a Gallic racial characteristic? I doubt it. The answer is probably that several generations of painters, notably those of the 19th century, established principles of harmonious color combination, and we have come to accept such color arrangements as harmonious. Painters may now rely on this precedent for the tasteful use of color. The Germans, on the other hand, are in our time notorious for their unrefined color

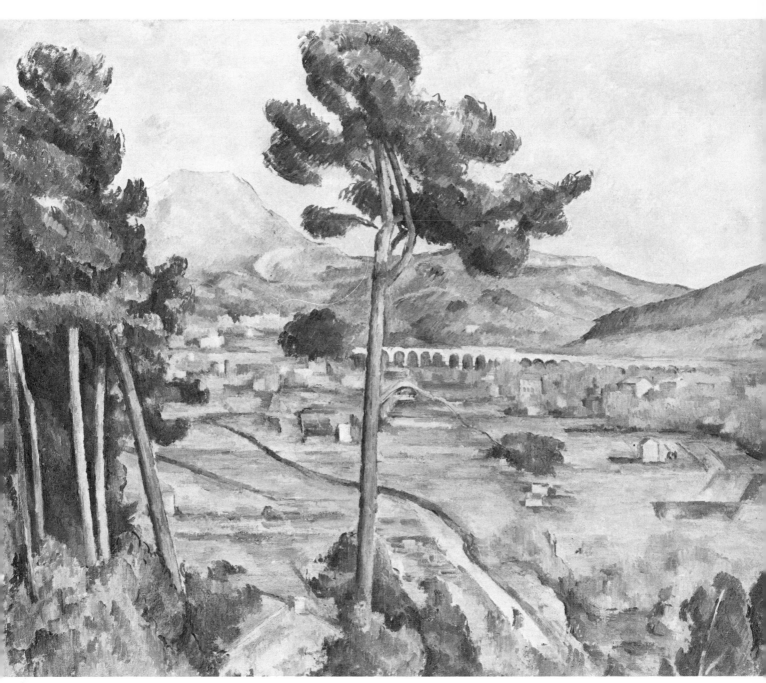

FIGURE 1
Paul Cézanne, LANDSCAPE WITH A VIADUCT

sense, but are superior in architectural and interior design. Therefore it is only when viewed from long perspective that sundry tribal quarrels and time-tastes fall into a definite pattern whence issues that ineffable thing—good taste.

One day, as I passed the window display of an auction house in New York City, I stopped—transfixed—to examine a work of the revered 19th century academician, Bouguereau. There in a garden sat a young girl contemplating a flower in her hand. What a sadly sweet expression enlivened her countenance, how touching her bare feet. The subject was painted with miraculous skill—equal (except for the use of the paint material) to the work of Raphael. However, Bouguereau had no license to indulge in such Raphaelesque sentimentality; his time did not afford him that privilege. His painting, removed from the realm of the sublime—is instead sentimental, insipid. Because of the spuriously lachrymose treatment of the subject, it fails to qualify as a great work of art, despite the fabulous draftsmanship and skillful execution. In short, the Victorian Age did not give its artists an aesthetically valid convention that prevailed at a time when all artists worked within the confines of an all-embracing obligatory reference—that of a collective style.

The old masters, on the other hand, were not concerned with problems of good or bad taste, and were not obliged to establish, each for himself, a tasteful manner of presentation. In all periods of history up to the beginning of the Machine Age, the style of the time, in which all artists shared equally, controlled and regulated taste. Thus minor painters in command of their craft could produce estimable works of art; and even when dealing with trivial, sentimental or coarse subject matter they seldom transgressed the bounds of good taste. Recall the genre pictures of the so-called Kleine Maesters of 17th and 18th century Holland—the faithful depiction of scenes from domestic life, the brawls of drunken peasants in village inns and similar trivial go-

ings-on which, supported by current style, managed to retain artistic validity; then consider how a 19th century painter, in treating lowly genre subjects, failed dismally in achieving valid aesthetic expression.

You and I, all of us, were born with unrefined taste. The unschooled eye is as a rule, attracted by the ordinary, the ostentatious, the commonplace. Only by a wearisome process of distillation, education and research do we learn to distinguish what is, and what is not in good taste. By lending one's eyes and ears to great works of art, whether in painting, sculpture, music or architecture, one will eventually come to understand what makes these works great. Once the senses are conditioned to the noble and exalted, it is not likely that an individual will ever again enjoy the vulgar and tasteless—except when he does it under some psychological compulsion.

In acquiring good taste one usually goes through a process in which he is first enamored of, and subsequently disenchanted by a series of "eyesores." An eyesore is an object conspicuous for its bad design, bad color, or both. What are the geometrics of a bad design or a tasteless conception, what chromatic clashes account for bad color? On what authority is a thing decreed to be in good taste? It would seem that what is, or what should be, aesthetically acceptable is a matter of empirical knowledge that is—experience. But this is not always true, for a new category of art outside the compass of our experience may temporarily escape recognition as worthy of the term "beautiful."

When looking at a work of art, value judgment should be divorced from the propensities of one's personal preference, else we may find ourselves in the invidious position of admiring the wrong thing and being indifferent to a great work of art. If I should now say that I prefer the etudes of Chopin to a Beethoven piano concerto, you might say that I lack discrimination—if I did not speedily concede the superiority of the latter, or give you the reason for my preference. Similarly, I feel totally uninhibited in expressing my prefer-

ence for an Arnolfo di Cambio or Niccolo Pisano over Michelangelo who, on my scale of values, ranks first. The formation of an attachment to works of lesser magnitude—or no magnitude at all—is a matter of arbitrary preference. Value judgment, on the other hand, should be objective; it should be guided by concrete qualities that can be precisely classified.

What is it, then, that makes a particular work of art great? A simple, incontrovertible answer is: the amount of talent invested in it. *Talent* is a vague term; a simpler way of expressing this quality might be to say "the difficulty of doing it," for it stands to reason the more difficult an achievement, the more singular it becomes. The term *amount* suggests a certain numerical value which may, for the sake of simplicity, range from zero to one hundred—the first representing the artistic potential of a nonentity and the latter, genius of the first order—the apotheosis of man as creative personality. Within this context, we can then classify minor and major genius by using a method of fine calibration and comparison. As to the "difficulty," it is self-evident that it is not of technical nature, but that it encompasses all the imponderabilities enmeshed in a fabric of a work of art.

All judgment is reached through comparison; in fact, language itself is vested in a system of comparisons. Thus, we may describe anything as "greater," "better," or "more efficient" than something else. When confronted with a violin of cheap modern manufacture, for example, in the absence of a sweeter-sounding and better-looking instrument, we should be unable to conceive its inferiority without an Amati, a Guarneri, or a Stradivari for comparison. Similarly, a faster racehorse is considered superior to one less endowed. The reason a dancer becomes a prima ballerina is at once apparent when we compare her performance with that of a dilettante. The crux of every judgment is the acceptance of a paradigm of excellence.

To be an effective basis for judgment, comparison must be confined within specific categories. We can say that Dürer's graphic work is superior to that of his contemporary Lucas Cranach, but not of greater artistry than that of Rembrandt, whose draftsmanship rests on entirely different premises. Yet, the *artistic potential* of both Dürer and Rembrandt reaches the highest point on the scale of artistic attainment, previously referred to as the "amount of talent."

Unlike music, paintings do not generate emotions other than those which I categorized as "aesthetic," as Nietsche put it: *"Vermöge der Musik die Leidenschaften geniessen sich selbst,"* (Through the medium of music the passions feed upon themselves). When listening to so many works by Beethoven, Mozart, Schumann, Schubert, Mendelssohn and other great composers, I am reduced to tears. This does not happen when contemplating paintings, sculpture or architecture; here we are confronted with visual ideas, and our responses are purely aesthetic and cerebral. Specific emotions such as love, pity, hate, compassion, and sadness are wholly non-aesthetic. This implies that the infiltration of human emotion into a work of art interferes with its aesthetic matrix, although in a certain historical context the human element was the vortex of most art. Such were the religious paintings and sculptures of the Middle Ages, the moralizing epics of the early Flemish masters—yes, even the anecdotal art of 17th and 18th century Holland.

The basic criteria of criticism lie in fundamental aesthetic principles. Some of these principles are immutable, while others retain their artistic validity only within a historical frame of reference. When applying value judgment within a historical context, we may find that an art object—or perhaps an entire art movement—is, on the whole, not of a high aesthetic order, but is very important in the development of art. Impressionism is a case in point. Conversely, a work of great aesthetic significance may have no importance at all in relation to art history. Thus, when examining the subject matter of a work of art we should first inquire: is the pictorialization of that spe-

cific situation desirable, and is it altogether feasible? A subject that was legitimate at one time may be unacceptable at another; it may have become trivial and sentimental—a repertory of clichés.

What meets our eye when we look at a painting? Which of its aspects should we take under scrutiny? We must examine its composition, paint quality, and color; we search also for its imaginative aspects and the evidence of a personal approach. This may appear to be a pedantic, doctrinaire catalogue (not to be confused with the *obiter dicta* of the 18th century French art critic Roger de Piles) but in point of fact it encompasses all the nameable elements of a painting. The criteria mentioned are, of course, traditional and are out of currency in the modern aesthetic; in their quest for "ultimate freedom," the proponents of that aesthetic fail to comprehend that art's freedom lies in its submission to the law, and art can only develop when there is a convention to which new artistic ideas can be linked. "To excel the past we must not allow ourselves to lose contact with it; on the contrary, we must feel it under our feet, because we have raised ourselves upon it" (Bernard Berenson). In rejecting the artistic past, the devotees of modern doctrines have made lack of discrimination their principle *modus operandi*. This system abjures all conceptions of the qualities we have known in the past, and has solemnly legislated that anything may be called "art" as long as it is accepted by the influencial preceptors of modern aesthetics.

In the evaluation of a painting the first consideration is composition. What then is its nature, its pragmatic character? The basic elements of composition are harmony and balance; this is simplistic, yet these elements encompass the facets of composition in all their complexity. Harmony and balance offer more than mere aesthetic gratification; their implications are, as it were, of cosmologic magnitude, for they are part and parcel of the Universal Order. I am aware such a claim sounds extravagant, and I could quote from illustrious sources—philosophers and archi-

tects who searched for the transcendental axioms of harmony and balance. Suffice to say exigencies of a prevailing style or temporal mutations of taste have no influence on the system; they do not legislate the presence or absence of these attributes in a composition. When you move a limb away from your body, fold your arms, shift the position of a chair in your room, this all lies within the precincts of composition. We do not have to indulge in theosophic speculations to realize the universe is governed by Universal Order. A painting may be indifferent as regards color and paint quality and still retain a high rank as a work of art, but if its composition is faulty, inevitably the picture becomes defunct. This does not imply, however, that good composition *ipso facto* establishes the excellence of a work of art. Harmonious composition should be a matter of course; this is expected even in the work of insignificant practitioners. However, the disposition of a pictorial arrangement may be so complex, or so ingeniously organized that only a great master could boast of such an accomplishment.

Turning from the fabric of theories to the mechanics of classic picture composition, the conditions of harmony and balance are governed by two subsidiary underpinnings: coherence—unity—and emphasis. In a coherent composition, every element of color or form maintains its preordained position in the picture's plan—nothing can be added or eliminated without disturbing the balance of the whole or creating a vacuum in it. Emphasis brings the narrative to a dramatic climax.

As an illustration, let us now examine one of the most stupendous paintings in all history, Albrecht Altdorfer's *Alexander's Victory* (Figure 2). The panel measures 63 by 37 inches. Consider first the sky: here is celestial space endowed with imagination of such velocity and cosmic dimension so great that it could only have been created by a talent of the first order. The lower third of the panel is filled with literally thousands of warriors attired in their medieval best, many mounted on magnificently caparisoned horses. The fig-

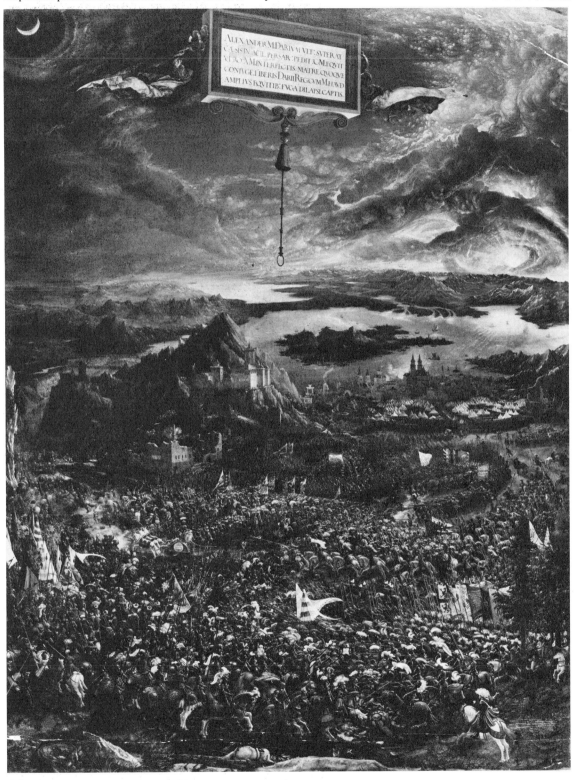

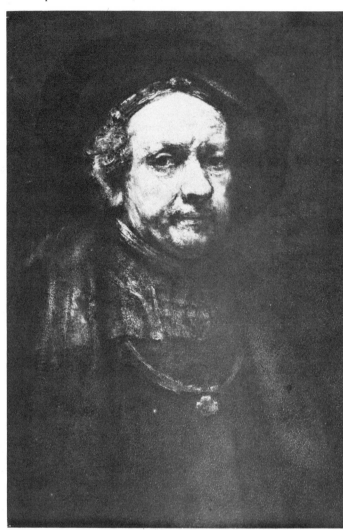

FIGURE 3
Rembrandt, SELF PORTRAIT

ures are in sharp focus, with a wealth of epic detail minutely elaborated. As a technical performance alone, this painting is intricate beyond belief—a stunning example of phenomenal craftsmanship. Here skill creates an aesthetic system of its own—a formal language in which it reaches its ultimate eloquence. Why, then, can we not count *Alexander's Victory* among the greatest masterpieces? Because its composition is at fault. The miniaturistic conception of the figures in the lower third of the picture and the broad treatment of the landscape are discordant; hence the painting fails in terms of formal unity. Because the consonance between the constituent parts is missing, it lacks the all-embracing, soul-satisfying forces of harmony and balance.

A second consideration in the evaluation of a painting is the nature of paint quality. What happens when an artist takes brush in hand, fills it with paint and applies the paint to the surface of his painting? Paint quality is generally considered to be the result of craftsmanship—dexterity brought about by diligent application, but in addition to acquired skill, paint quality is influenced by the personal nervous mechanism of the artist's hand. To envisage its nature, place side by side a Rembrandt and a Carel Fabritius (Figures 3 and 4). Clearly, Fabritius' skill is considerable; yet, the paint quality in the work of Rembrandt stands on an incomparably higher level.

Hence, to define the term we shall have to split it into its components. The difference in the surface appearance of paintings lies in *texture, brush stroke,* and *contour.* These characteristics are not entirely the result of manual dexterity, for identical technical proficiency will not yield equal artistry in the handling of texture, brush stroke and contour.

Texture refers to the tactile qualities of the paint surface which represents certain objects. The fact that surface quality may differ

18

from object to object was recognized early in the history of painting. So we read Vasari's reference to Bellini's texture of fur, silk, and velvet, which ". . . appeared like the objects themselves." Hence, the representation of textures served at one time to attain verisimilitude. Once this objective becomes immaterial, the painter's range in exploiting the sensuous qualities inherent in tactile values is vastly enlarged. In some of the nonobjective paintings the preoccupation with textures *per se* has, indeed, enabled the artist to produce the most varied and enticing topographic configurations. However, to endow representational subjects with significant textural effects presents infinitely greater problems.

The recognition that brush strokes are the painter's handwriting, expressing his particular sensibilities—the nervous mechanism of his hand—dates only from the time of the late Renaissance, (mid-16th century). Before then, most artists labored to erase all evidence of brush strokes from the surface of their paintings. Today, for certain groups of artists, brush strokes and textures have assumed an autonomous function and no longer serve representational purposes. Abstract Expressionists in particular employ these devices as ends in themselves to exercise, with utter abandon, the painter's undifferentiated neuromuscular impulses released at random.

Contour refers to the quality of lines—

The Metropolitan Museum of Art, New York

FIGURE 4
Carel Fabritius, HENDRIJKE STOFFELS

19

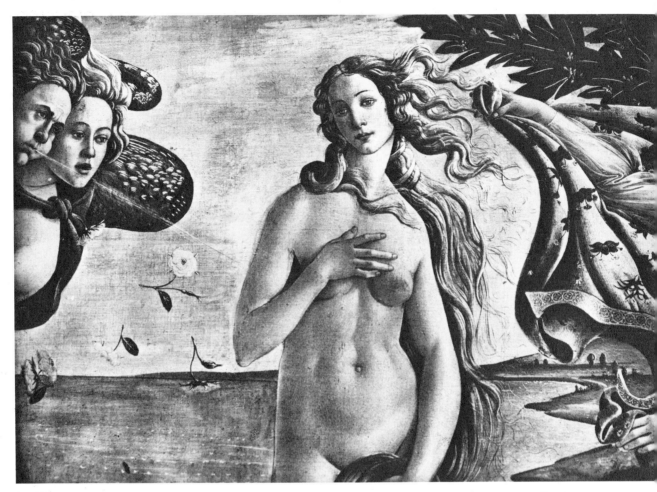

FIGURE 5
Sandro Botticelli, BIRTH OF VENUS (Detail)
Melodious withal.

Uffizi, Florence

visible and constant as you see them in a
painting, in music they are audible and in
motion. The circumambient contours of fig-
ures in Botticelli's paintings (Figure 5) con-
ceived by our eye as if they were palpable
lines—don't they have a musical quality?
They are extraneous, circumscribing the ob-
jects in hard outlines as in Byzantine painting
or freely orchestrated as in an El Greco (Fig-
ure 6), often almost non-existent and in vague
confluence with the surrounding space, as in

a Rembrandt. How much art would be left in
an El Greco without the symphonic orches-
tration of his contours, in a Frans Hals
(Figure 7) without the bravura of his brush
strokes?

The concern of artists in handling con-
tour reaches into antiquity. In the first cen-
tury A.D. Pliny had this to say on the subject:
"The painting of contours requires
the very highest skill. To paint sub-
stantial bodies and the interior of ob-

20

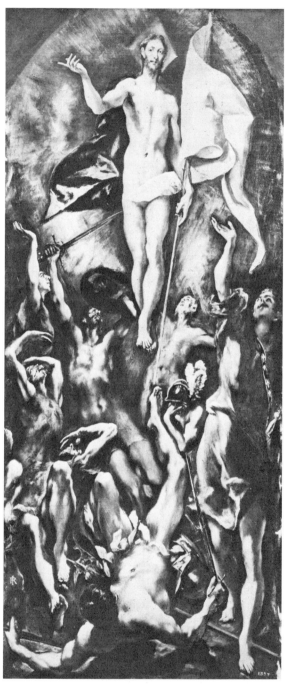

FIGURE 6 Tavera Palace, Madrid
El Greco, ASCENSION
Ecstatic transfiguration.

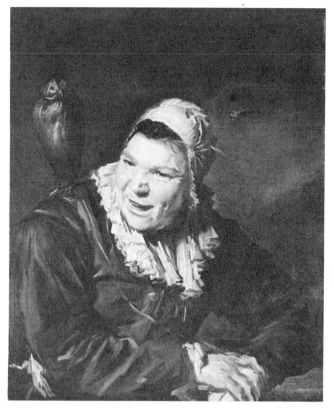

FIGURE 7 The Metropolitan Museum of Art, New York
Frans Hals, MALLE BABBE
Unsurpassed mastery of the brush.

jects is a great thing, no doubt, but at the same time it is a point in which many have excelled. To paint the extreme outline of a figure, and to round it off—this is a success in art which is but rarely attained. For the extreme outline to be properly executed requires that it be nicely rounded, and so illuminated as to prove the existence of something more behind it, and thereby disclose that which it also seems to hide."

In Pliny's time the rigid contour was considered a sign of "primitivism," in contrast to the "enlightened" conception which emphasizes the roundness of objects, by softening the outer outline often to the point of fuzziness. Curiously, in the ensuing centuries, artists made no attempt to "round off" contours so

as to endow an object with ostensible three-dimensionality. Thus they earned for themselves the epithet "primitive." It is difficult to believe that early in the 19th century the term "primitive" was ascribed even to Botticelli, and it was meant as a denigration!

A third element of painting we must consider when assigning value judgment is that of color. In the compound of a picture the function of color may be decisive, or a painting may be treated entirely in monotones without losing artistic significance. The dependence on monotones, that is broken colors that provide tonal values came into full use during the late 16th century. Byzantine and Gothic painting relied almost exclusively on pure color. The use of broken colors—colors deprived of their high key by the addition of white—facilitates their interpenetration.

As any practicing painter knows, employment of such colors offers the least risk of failure, whereas the use of pure strong color can raise problems. Here difficulties are many and appear at every step—except in painting flowers and nonobjective motifs. Just as in a flower bouquet, where an assembly of clashing chromatic effects will not jar our sensibilities, so in a nonobjective painting we cannot speak of "good" or "bad" color.

Place on your palette the entire list of colors and sweep them together at random with a painting knife and the coloristic effect thus produced will be spectacular, for there are no bad colors or color combinations, as long as they are not attached to objects. But, consider a landscape, its sky tinged with purple, the trees sporting a brilliant orange, and a lake painted in pure Capri-grotto blue—an atrocious combination to be sure—a kitsch of the lowest order. Likewise, the figure of a woman attired in a similar combination of colors will surely make you wince. We react in this manner because, in the matter of colors, we rely on established precedents of "good taste."

The final stage of our study and evaluation of a painting is the consideration of the intangible qualities—*imagination* and *originality*. These agencies touch the artist's performance at every turn. Imagination is a condition in which the ostensible image disengages itself from the factual. By translating objects into different equivalents, imagination seeks out their elusive elements. It allows the painter to charge his images with all kinds of poetic intimations, endow them with overtones of otherness, lend them oblique meaning and provide aspects that cannot be arrived at from surface impressions. The human figure, for example, can be visualized in many ways; its images can be ornamental, clinical, erotic, ritualistic, symbolic—even metaphysical.

Imagination is an integral part of originality, a concept misunderstood, abused and tossed about freely. True originality is seldom identified as such by contemporaries. As a rule, an artist gifted with great originality remains unrecognized during his lifetime; without the advantage of historical perspective, what passes for originality are its disguises: mannerism, obscurantism, eccentricity. Originality, like naiveté, cannot be acquired; straining to achieve it will always result in failure, true originality arises from the inviolate region of the unconscious. Originality cannot be equated with unconventionality, for it functions only as a new facet of a conventional concept. It does not abrogate tradition; it can never be obtained by neglect of tradition; its presence signifies the development and enlargement of tradition. In the history of art we see again and again that originality is strongest where indebtedness to the past is greatest.

The relative importance given to originality in the history of art varies. There have always been artists whom we may call pio-

neers, but their importance is more often historical than aesthetic. Very often, a derivation can be superior to the original which serves it as an example. There are always initiators and perfectors among artists. The former, as a rule, exhaust their creative faculties in straining to find new, untrodden paths; hence it remains for those who follow to lend perfection to these new forms. Such are the processes throughout the history of art. The early Greek sculptors gave greater realism to the Egyptian interpretation of the human form, and their successors in the Golden Age made it still more life-like. By "imitating" the Greeks, the Romans succeeded in enhancing their forms with greater vitality, variety and authenticity. While Giotto remained within the domain of his master Cimabue, he created masterpieces under the influence of Byzantine style; but when he endowed his images with realism in the 14th century mode, the aesthetic appeal of his paintings weakened. It remained for the masters of the Renaissance to make his realism "real." At this occasion we may consider Boccacio's words on Giotto: "There is nothing in nature that he would not imitate so well as to deceive our very senses, making them imagine that his painting was the very thing itself". Giotto a realist! What a strange statement.

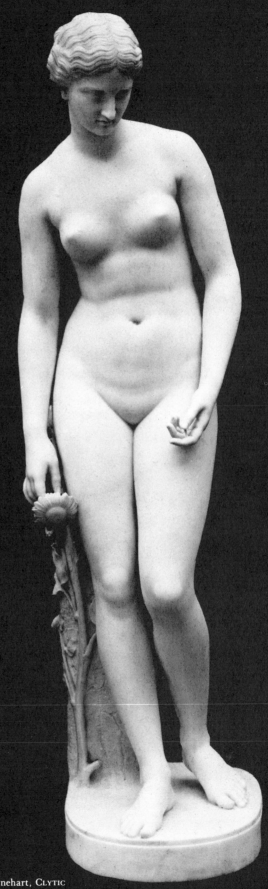

FIGURE 8
William Henry Rinehart, CLYTIE
The Metropolitan Museum of Art, New York

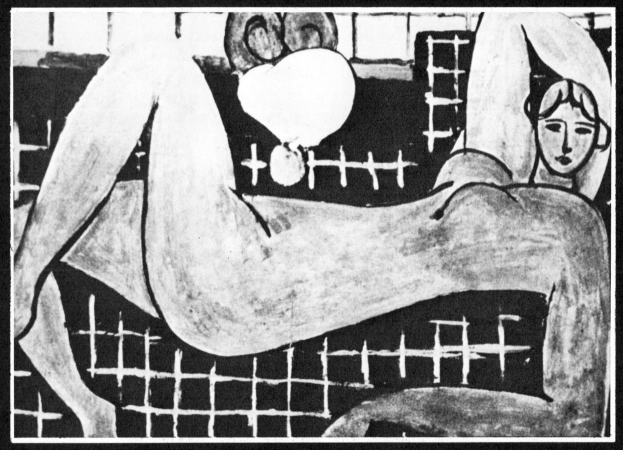

FIGURE 9
Henri Matisse, PINK NUDE

Studies in Contrast

IN THE REALM of aesthetics and many other disciplines value judgment can be reached only through comparison. The basic criteria set forth in the previous chapter—good taste in the choice of subject matter, harmonious and balanced composition, skill in the use of the medium, and imagination and originality—are immutable. They are as valid today as they were anytime in the past. In acknowledgment of our debt to those who have gone before, I shall attempt here to elucidate the intrinsic qualities of the paintings of the old masters by comparing them with one another.

Pieter Brueghel—Jan Steen:
Grotesquerie and Caricature

A CENTURY AGO the name Pieter Brueghel had no particular resonance. He was considered a humorist, an illustrator of vulgar bucolic life; he was nicknamed "Peasant" Brueghel. The Gothic element in his work offended the refined tastes which were taught that classicism is the only measure of beauty. And no wonder, for his paintings indeed lack the formal dignity which is part of the fabulous Renaissance scene—or at least it is dignity of a different sort. Brueghel types are not expressive of classic humanism, of its aesthetic predilections, its love for serenity or classic proportion; his compositions are Flemish—that is, Gothic of the kind to which Michelangelo, with his bias for classic composition, referred contemptuously as provincial, barbaric, crowded with obscuring elements. Gothic, it should be remembered, had stood since the time of Raphael for "barbaric"; the grotesque, the odd, the macabre are in many instances its distinguishing traits—and connoisseurs for many generations have not cherished these qualities. Yet Gothic expression carries a vitality surpassing anything found in the classic. Implicit in the ultimate Gothic aspiration to Heaven is a keen sense of Purgatory and Hell. And if Brueghel is not always Purgatory-bent, his work reveals an acute awareness of the constant presence of Satan. His humor does not come off smoothly. There is a bitter tang to it—quite unlike the humor of Jan Steen, who was also a narrator of rustic vicissitudes.

In Brueghel's work the immediacy yields to the infinite; the specific to the universal. His peasant is more than a type; he retains his rustic surface, but the surface becomes his core and his soul. No attempt is made to glorify the subject, yet put through the alembic of the artist's mind the vulgar is transported to the sphere of wonder, and the trivial achieves monumental proportion (Figure 10). Herein lies the particular genius of this painter, who is not after the symbolic; the allegoric, who faithfully depicts reality, yet lifts fact from the realm of the ephemeral and transmutes it into a timeless epic of human destiny. Brueghel's world is charged with diabolic melancholy. Above and about the animal life of the peasants lies the heavy hand of fate: mirth prefigures a last reckoning, and wickedness, retribution; unresolved love foreshadows hate, and despair, a final redemption.

Like the peasant—the earthbound creature who is a mirror of universal forces—Brueghel's landscapes are not particularly city or country vistas, they are visions of a fantastic world. In his *Hunters in the Snow* (Figure 11), most of the details are literal and authentic, but the landscape is pure invention. Here is the spirit of winter, of snow, of cold gray distances where enchantment lurks beyond hazy horizons—the breath of eternity hovers over the scene. The people—hunters and skaters—the hounds, the crows, the kitchen crew busily fanning the fire, do not bring the majesty of the frozen world to our own scale and measure, they do not carry it down to earth, nor do they evoke in us a sense of the homely and familiar. Rather, they deepen the imper-

FIGURE 10
Pieter Brueghel, PEASANTS DANCING
Not merely an illustration of rustic jollification.

Kunsthistorisches Museum, Vienna

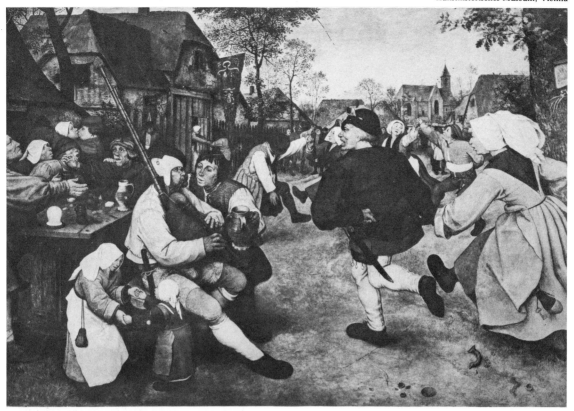

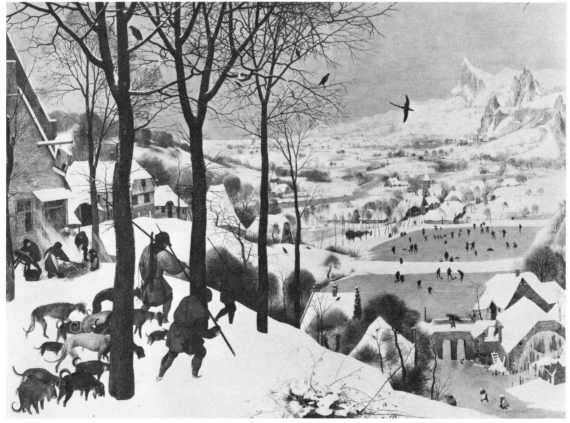

Kunsthistorisches Museum, Vienna

FIGURE 11
Pieter Brueghel, HUNTERS IN THE SNOW
Breath of eternity hovers over the landscape.

sonal detachment of the haunting distance, the mystery of the dormant fields and trees, the threat of the ghostly cliffs. *Hunters in the Snow,* one of the greatest landscape paintings of all time, is perhaps the supreme test of the painter's masterly sense of composition and subtle use of color. No histrionic stunts, no brilliant effects contrive to please the eye. A variation of delicate incorporeal grays and pale gray-greens which fade as they recede into the distance; a touch of ochre here and there, the rigid black of the gloomy trees, and the glowing tongue of the open fire—these are the colors of the scene. Here, as in most of his compositions, Brueghel takes the foreground almost without transition into the distance, which mellows into a rolling cadence of hills receding into the picture's depth. It is all as simple as a child's picture book, but the simplicity is the end result of a complex process of sublime artistry.

In comparison with Brueghel's world, Jan Steen's, in *Peasants Quarreling Over Cards* (Figure 12), is populated by raucous yokels. Merry are they, but their ebullience is flaccid and their temper beer-propelled. There is animation and verve in the handling of the brush, there is skill, gusto. What, then, accounts for the painting's lack of significance? It is the artist's incapacity to avoid caricature.

Grotesquerie and caricature are twin sisters, yet so totally dissimilar. Here the element of taste and the depth of insight determine the painter's attitude toward his subject in particular, and the human condition in general. Grotesquerie and caricature employ exaggeration and deformity in like measure and push all issues to extreme conclusions. It is not, then, the degree of aberration from the "norm" that determines the classification, but rather the nature of the artist's approach. Caricature is—intentionally or not—comical, ludicrous and doleful; its means are external, its purpose is often didactic. The grotesque, on the other hand, is a condensation of the wierd and diabolic; through it the hidden, often tragic reaches of the soul find expression. There is nothing grotesque in the quarreling peasants—here the obvious and trivial rule the scene.

FIGURE 12
Jan Steen, PEASANTS QUARRELING OVER CARDS
Vulgar? Not when represented in the 17th century style.

29

Velazquez—El Greco:
Realism and Dramatic Improvisation

REALISM HAS ALWAYS derived its axioms from ideologies imposed by institutionalized customs. For some of the Renaissance masters, it was the probing instrument of science; its essence was a passion for verisimilitude, exactitude, perfection. Local attitudes of every period are identified with what was considered "true to life" at that particular time. As institutions wax and wane, so the concept of reality changes—from day to day, from age to age—a phantom, the chimerical fabric of our sensibilities. Can we, with reasonable certainty, define and delimit the criteria of realism? What are the precincts and limits of visual acuity? The more closely we behold an object, the farther, it seems, its image removes itself from our comprehension. Reality—the most elusive and volatile of all matters—he who finds it has the key to art.

When a painter directs his efforts to the achievement of realistic representation, his first obligation is to divest himself of the frills of vanity with which he drapes his artistic expression. He must subordinate his mental attitude only to that which he can visually apprehend. This brings us down to earth, and to Velazquez, the realist par excellence—the prototype of the classic academy. He was the model for all the epigones who tried to emulate his art, but who never reached the level of their master's achievement. Recall the clumsy and tedious manner in which most of his imitators handle detail—how differently it is treated by Velazquez. How fleetingly his brush caresses the forms, unburdening them of all that is fussy or rigid; how subtly he contrives to bring detail into the orbit of faithful servitude.

The achievement of equilibrium between the minute figurations and the large masses—the particular manner of arrangement—the way in which the elements coincide, or as the case may be, oppose one another—all determine whether a composition is mediocre or masterly. In *Surrender of Breda* (Figure 13)

point and counterpoint rule the field; uniformity plays against multiplicity and the total effect is one of supreme aesthetic gratification. Consider the sky: clearly, it must have been raining just a while ago, and now the air is washed clean; the clouds have thinned, and some of the late sunlight brightens their edges, suffusing the scene with a mood of poetic reverie—a conception totally alien to modern aesthetics. A sentimental narrative, a pictorial anecdote, one might be tempted to say—but not when handled by Velazquez. How subtly the dramatis personae, the contestants, are isolated from the crowd by device of ingenious design. The helter-skelter of the heads on the right is pacified by the dark mass of the horse, and throughout the composition every thrust is met with relaxation, every strong utterance with eloquent silence. Velazquez did not arrive easily at the final statement; painstaking corrections were his daily task. For example, at one time the lances carried banners, giving the picture a garrulous note; these were later overpainted, and further investigation reveals a second set of legs that once belonged to the horse.

Wherein lies the enigma of *Las Meninas*, The Maids of Honor (Figure 14), by what agency does it probe our unconscious? Here the artist operates with his customary parsimony of color; feather-light touches of the soft brush, Impressionistic bravura that disdains the "sweat and tears" approach when handling things material. To all appearances, nothing out of the ordinary seems to intrude upon the surface. Yet, beyond the mask of reality lurks a meaning we cannot grasp. To quote Vasari: "After weighing all the materiality of a work of art, there remain those portentous regions of depth and grandeur that words will never plumb." Ah, the unfathomable! I use the term with reluctance, because it lacks precision, and has little to do with value or judgment. It is a reaction formation—perhaps the result of self-mesmeriza-

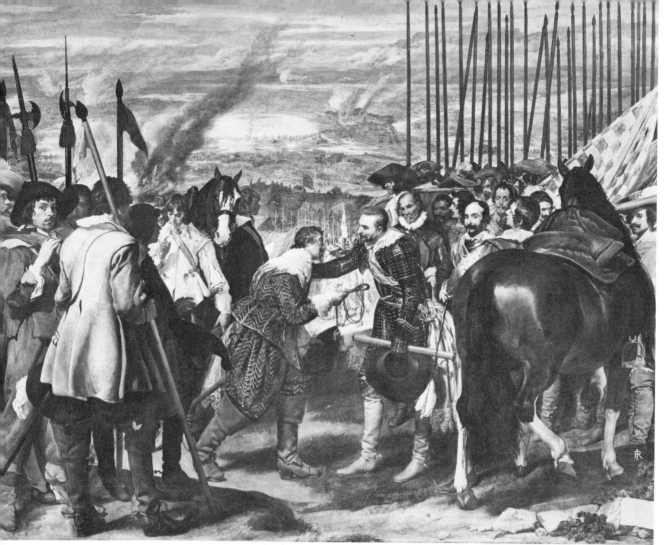

FIGURE 13 Prado, Madrid
Velazquez, SURRENDER OF BREDA
Epic grandeur.

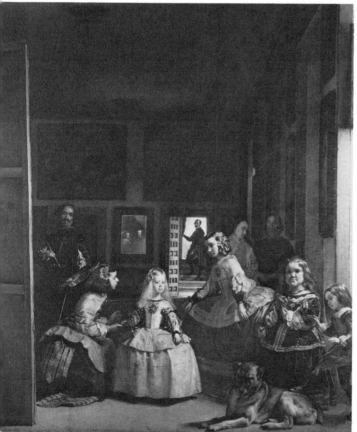

FIGURE 14
Velazquez, LAS MENINAS
It contains more than meets the eye.

Prado, Madrid

tion—does it sound extravagant to say that even the dog in this picture impresses us as having a transcendental aura?

All great art contains elements which are forever "modern." Whether they are recognized or remain undiscovered depends on the temper of the time. And so it is that only with the advent of Expressionism has the art of El Greco gained a full measure of recognition (Figure 15). Like the Expressionists, he indulges in an outward show of agitation, ecstatic theatricality, and all manner of exaggeration for the sake of his dramatic narrative. In his representation of the human figure he does not maintain the classic order, and the garments in which he drapes the figures do not display the realistic niceties we admire in the work of the classicists; "the manifold echoes of body movement," as Goethe put it. His images, illuminated by a forced chiaroscuro, underscore the depth and height of the colors and lend to the scene an aura of illusion. The quality of his art depends in large measure on a symphonic orchestration of the contours, which, like the sounds of an organ, fade and swell to a grand crescendo. Never in the history of art was the treatment of contours executed with such commanding freedom, a freedom born of improvisation.

"But we well know that the perfection and the special advantage of oil painting reside in the fact that one can retouch it many times. . . . Others carefully carry out the sketch, and for the finish they use free and bold strokes, wishing to indicate that they work with more dexterity and ease than others. And although they labor hard in doing this, they cover their effort with this device." So wrote Pacheco, Velazquez's father-in-law, himself a mediocre painter. When watching El Greco at work Pacheco wrote: "He started to paint in an orderly manner, observing all the proprieties such as we were taught, only to impose upon his finished painting those cruel alla prima strokes feigning valor." These quotations attest to the effect of improvisation. I do not wish to imply that a planned, precision-oriented work is necessarily of lesser merit than one resulting from proliferation of the painter's nervous impulses. However, when we compare El Greco's early "tight"—controlled— paintings with that of his mature years, the added significance of his spontaneous work becomes quite obvious.

Spontaneity is synonymous with improvisation, and this quality lies at the heart of a sketch. The word *sketch* implies an unfinished condition, and by suggesting rather than exposing, a sketch stimulates our expectations and fantasies. El Greco's late paintings have the aspect of sketches—they are the issues of unconditioned responses, and in spite of their aura of mannerism they are expressions of the painter's highest artistic potential.

FIGURE 15
El Greco, THE BURIAL OF COUNT ORGAZ

Church of Santo Tomé, Toledo

33

Rembrandt—Nicholas Maes—Frans Hals:
Virtuosity of the Paintbrush

THERE IS A general tendency to regard every work that carries an illustrious signature as a "masterpiece"—an illusion fostered coincidentally by the critics and commercial interests. In the art trade, references to "quality" are seldom observed, for in so doing a higher value would have to be assigned to a work by a lesser luminary if it is superior to the work of one designated as a "great master."

It is evident that even Rembrandt produced mediocre paintings. If we are to use comparison as the basis for judgement, it is reasonable to compare several paintings by the same artist, in addition to comparing his work with that of another artist of the same period and style allegiance. In Rembrandt's early paintings, for example, the principles of chiaroscuro are observed, but its conception is conventional. At this juncture the painter did not understand that the linear is at cross purposes with the luminous and gloomy. The objects in his early composition have rigid contours scarcely influenced by the action of light and shade. How different is the handling of chiaroscuro in his later work. Under the influence of light, the harsh delineations mellow and the shadows vastly deepen their impact. Only then does the art of Rembrandt reach its culmination.

In the paintings of Nicholas Maes, a pupil of Rembrandt, chiaroscuro is handled judiciously—but without distinction. His technique lacks the sensibility found in the work of his master, and the faulty composition destroys the harmony of the picture (Figure 16). By focusing our attention on the aggressive pattern of the spinning wheel, Maes suppressed the importance of the principal motif —that of the old woman. And what formal purpose can the solitary apple serve, placed forlornly in the right corner of the picture?

Frans Hals was the greatest virtuoso of the paint brush. Although skill with a brush is not rare among professionals, no other painter has equalled Hals' prowess in this particular area. Why, then, is he not accorded an acclaim equal to that of Rembrandt, whose brush work does not show the same virtuosity? The answer is that Rembrandt's paintings possess a quality totally lacking in Hals'—the quality of imagination. Of course, for Frans Hals or any portrait painter, the faculty of imagination is not a principal requirement, as it tends to interfere with the artist's intent to capture the factual image of his model (Figure 18). Rembrandt was not a portrait painter in the conventional sense, although he painted a great many conventional portraits; compare the painting commonly known as the *Night Watch* (Figure 17) with any of the numerous group portraits by Frans Hals. It is no exaggeration to say that by using commonplace burghers as models for the *Night Watch*, Rembrandt created enigmatic images of transcendental significance.

Another technical consideration necessary to the establishment of the aesthetic climate and significance of a painting previously touched upon is the handling of contour—the outline or boundary which defines the shape of an object. Not all objects must remain isolated within their given contours; some may achieve interpenetration with their surroundings, and their confluence, depending on the prevailing style, may be minimal or complete. In Rembrandt's work, the liaison between chiaroscuro and contour liberates the objects from their terrestrial confines and lends them enigmatic meaning. Light and shape merge in blissful embrace, and a celestial aura desubstantiates the contours and gently envelopes them in a mellow darkness.

At this point it is useful to digress briefly on the subject of chiaroscuro. The term refers to the interaction of light and shade—the use of light and shadow to create form and substance. It comes from the Italian *chiaro*, meaning clear, and *oscuro*—obscure. Illumination may appear in the form of a light shaft entering through an opening such as a win-

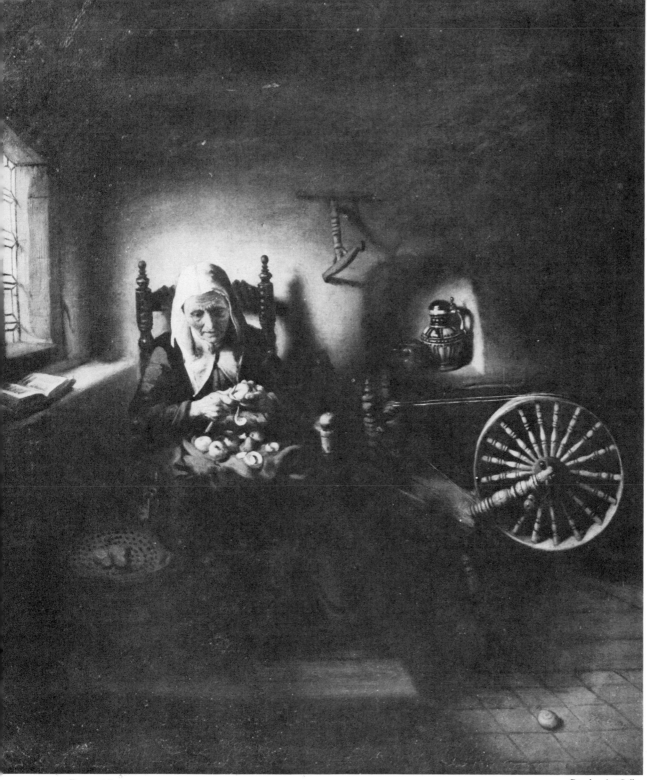

Figure 16
Nicholas Maes, Old Woman Peeling an Apple
Very far removed from his master, Rembrandt.

dow, or in a landscape it may be the focal —
not dispersed — light of the sun.

Generally, the character of illumination
in a painting depends on the prevailing style.
One of the first references to the painter's
concern with the problem of chiaroscuro

comes to us from Apollodorus. At the end of
the 5th century BC., he is supposed to have
introduced cast shadows in his figural com-
positions, thus stressing their three-dimen-
sionality; this interaction of light and shade,
more than any other device, accentuates the

35

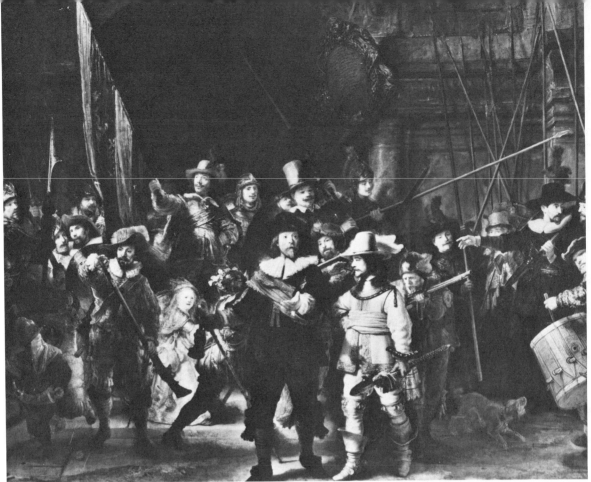

FIGURE 17
Rembrandt, THE NIGHT WATCH
A gathering of common burghers given transcendental meaning.

plastic quality of an object. In the Roman painting preserved in the murals of Pompeii and Herculaneum, we find dispersed light as well as focal illumination. Chiaroscuro does not appear in medieval paintings, which depend for their strength on brilliant color, for when obscured by shadow, colors lose their resonance.

In the paintings of the late Renaissance, the capacity for effective illumination of figural and landscape motifs became an important element in the index of an artist's ability. Leonardo da Vinci's subtle and original use of light and shade is his greatest artistic achievement. Later, the Baroque and Mannerist painters were engaged in exploiting the dramatic device of illumination, and a generation later Rembrandt's genius attained the almost unattainable—the divination of mys-

teries that dwell in the realm of adumbration to which—incidentally, John Ruskin, the astute Victorian connoisseur, referred as "dull, muddy, impious."

The painterly qualities of brush stroke, texture and contour must be fully taken into account when judging Rembrandt's painting. Indifferent and lacking particular character as they appear in his early work, these instruments of pictorial expression reach their greatest potential in his later, mature work. As the action of the brush reveals the nervous mechanism of the artist's hand, it vastly enriches the repertory of his sensibilities. This freedom did not prevail during the early Renaissance, because the artists using the oil medium were still influenced by the tradition of their predecessors who painted in tempera, and hence did not possess equal technical means.

36

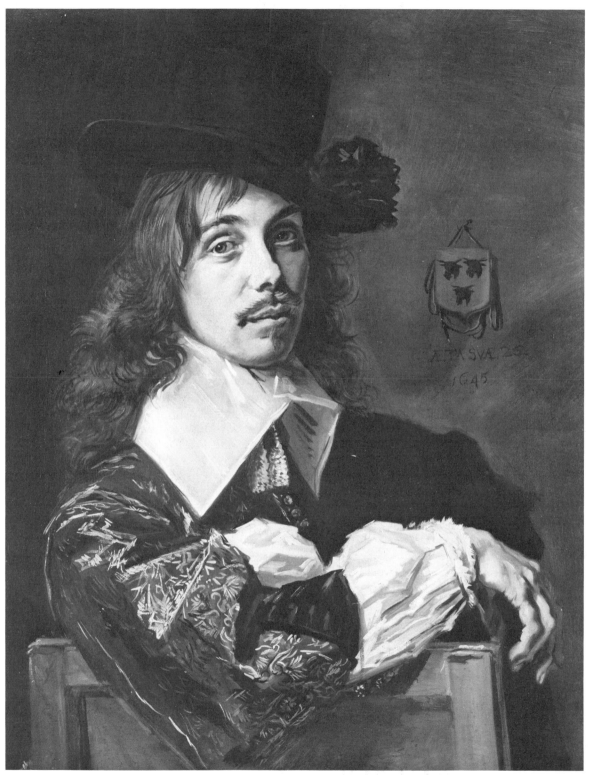

FIGURE 18
Frans Hals, WILLEM COYMANS

37

Rubens—Jordaens:
Morals and Aesthetics

ON SEPTEMBER 13, 1621, Rubens wrote to A. Turnbull, who was acting on behalf of Sir Dudley Carleton, English ambassador at the Hague: "I am quite willing that the picture painted for my Lord Carleton be returned to me, and that I should paint another hunting piece less terrible. . .making abatement as is reasonable for the amount already paid, and the new picture to be entirely of my own hand."

No doubt the great artist aimed to please. Unlike Rembrandt, the cosmopolitan Rubens, cavalier and elegant courtier, did not disdain to meet the wishes of his employers. This does not imply that the artist suffered character weakness which impaired his talent and lowered the standard of his work. "When his judgment is superior to his work," said Leonardo, "the artist never ceases improving —if the love of gain does not retard his progress." It follows, then, that a disregard for gain should further the growth of genius. This, of course, is not necessarily true. Titian, Michelangelo, Rubens, and many other great artists, keenly appreciated material rewards. Moral ascendancy is unrelated to the powers that generate aesthetic values; moral and aesthetic preoccupations dwell on different planes, each having a different field of opera-

tion. Moreover, sincerity is not a substitute for talent. Whether or not a painter is capable of compromising is determined not only by the pattern of his personality, but by the nature of his talent. Within the compound of his talent, two elements—facility and versatility—make it possible for him to comply with the (usually dubious) taste of his employers. A man of versatile talent can apply himself in many ways other than his very own. A painter who is not facile will escape many a pitfall, not because of his reluctance to sacrifice principle to circumstance, but because of his inability to conform.

There are, in fact, many mediocre "Rubenses,"some he merely retouched, and some, though they carry his signature, never felt the imprint of his brush. But there are works by Rubens which, regardless of present-day predilection for one or the other mode of artistic expression, are examples of the finest painting our civilization can boast.

But, it is useless to assure our contemporaries of the great aesthetic values of a Rubens painting if they are unable to appreciate them, for his work is the embodiment of the Baroque style, a style totally alien to our own time. The present-day attitude is, notwithstanding a token respect for the venerable

38

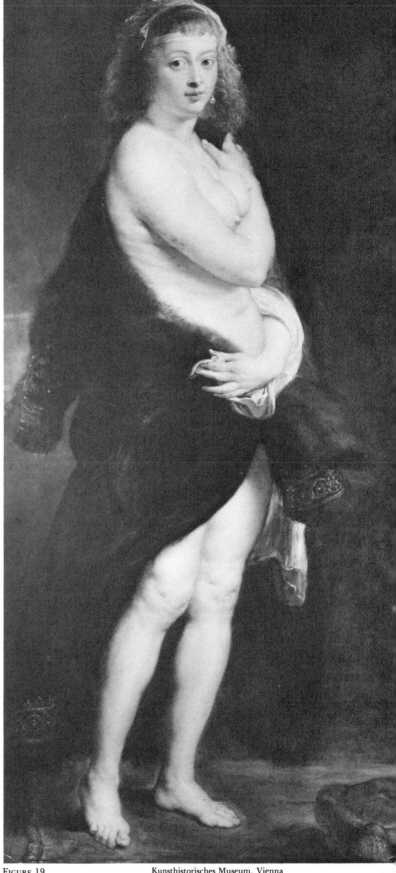

"old master," essentially indifferent. The reason for this is simple: the public, as well as the critics, are, as a rule, poor judges of paint techniques and their significance in the sum total of a painting's aesthetic merits.

Understanding technique is an important precondition to value judgment. To fully comprehend Rubens' eminence as a painter, so eloquently demonstrated in *Helene Fourment in Fur* (Figure 19), we must understand his working method, the character of his technical procedure. This account of Rubens' technique written by Velazquez casts some light on the subject. Under the very eyes of the Spanish master, Rubens, who was then a special ambassador from England, produced in less than five months the following paintings: "Five life-size portraits of Philip the Fourth, of which one was equestrian; a portrait of the Queen; several portraits of Infantas; ten copies after originals by Titian; a life-size *Saint John;* and a *Immaculate Conception* thirty feet square."

Such powers seem extraordinary, an act of sheer legerdemain. However, when one understands Rubens' method of painting, it is quite plausible that a life-size figure can be painted in a very few days. Rubens worked predominantly alla prima — without previous

FIGURE 19 Kunsthistorisches Museum, Vienna
Peter Paul Rubens, HELENE FOURMENT IN FUR
Sublime carnality.

39

underpaintings, aiming from the start at achieving the final effect. After the drawing had been transferred to the white support, a luminous imprimatura, (a thin transparent stain of color), was lightly brushed onto the drawing. The final painting (if of moderate size) was done in one sitting, swiftly, leaving the imprimatura, which served to unify the tonality of the painting, uncovered in many spots. Once the painting had progressed to this stage, any further corrective paint layers — that is, overpaintings — were kept to a minimum or, if possible, were avoided entirely. Such a procedure indicates spontaneity of rendition. (See my book The *Mastery* of *Alla Prima Painting*, published by North Light.)

Only those paintings by Rubens which show a swift and spontaneous execution fully demonstrate his great mastery. Only in these does he lose the heavy-handed carnal touch which characterizes his lesser works, (many of which were done in part or in total by his assistants). An over-labored Rubens invariably appears beefy, inane. The best of Jordaens and a mediocre painting by Rubens meet on the same plane, but a great Rubens is in a class by itself.

Poetic imagination, the faculty of sublimating the coarse and ordinary, is lacking in the work of Jordaens (Figure 20). He attacks the sensual with a heavy hand, as though he was afraid of not doing enough to his picture. Not knowing when to stop, he runs amuck. Under his brush, animation turns rapacious, appetite becomes gluttony. At the same time he is a virtuoso and a good colorist, but his artistry is tarnished by a coarse, vulgar conception.

Titian—Piero di Cosimo:
Classic Order and the Allure of Chaos

TODAY THE CLASSIC principle has lost its former appeal and validity. The bastardization and banalization of the classic has resulted in debasing the measured and the harmonious into slick clichés. The classic style, as it aspires to perfection—is of low vitality—it lacks drama. Because of the nature of the principles upon which it is founded, classic art cannot indulge in extravagance—exaggeration, distortion, because that is excessive, all runs counter to classic principles.

In the work of Titian and others conditioned by similar ideology, the classic confronts us first. Of course there are variations and modifications of classic style, but classicism is the core and root of Titian's art. One might say that Raphael's work represents a more perfect example of classicism. His drawing is no doubt superior, although we would hardly subscribe to Michelangelo's statement that, "Titian would have been a great painter—if he had drawn better." Michelangelo, it appears, failed to understand Titian's painterly qualities; he did not perceive that Titian gives us the very essence of the painterly, and that in such a conception, line must always remain subordinate to form and substance.

The finest features of classic realism are displayed in Titian's portraiture. *Man with Red Cap* (Figure 21) is a case in point. Titian ideated the external likeness of his model in the classic spirit; his artistic aim was to ennoble the subject of his representation. Power without excess, persuasiveness through reticence, and nobility without pomp are expressed by the colors; firmness, stability and monumentality by the delineation of the figure. As an early work, it foreshadows plein-airism. The values in the flesh tints rely on delicate articulation of tonal nuance rather than on the use of chiaroscuro. The treatment of the fur, the garments, and the glove displays the very essence of the painterly.

When contemplating classic art, however, we miss the pleasurable shock of the unexpected. To quote Kenyon Cox: "The classic spirit is the disinterested search for perfection, it is the love of clearness and reasonableness and self-control...It asks of a work of art, not that it shall be novel or effective, but that it shall be fine and noble. It seeks not merely to express individual emotion, but to stress disciplined emotion and individuality restrained by law."

"Individuality restrained by law" does not bewitch our senses. More than anything else, the grotesque captivates the contemporary imagination, and the grotesque is predicated on distortion of form. That is why El Greco and Grünewald are closer to us today than Titian.

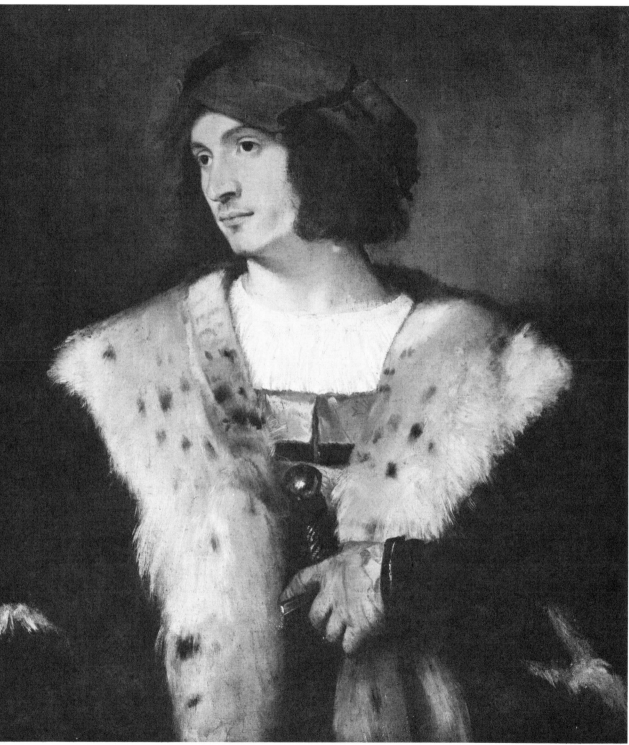

Figure 21
Titian, Man with Red Cap
Serene classicality.

Frick Museum, New York

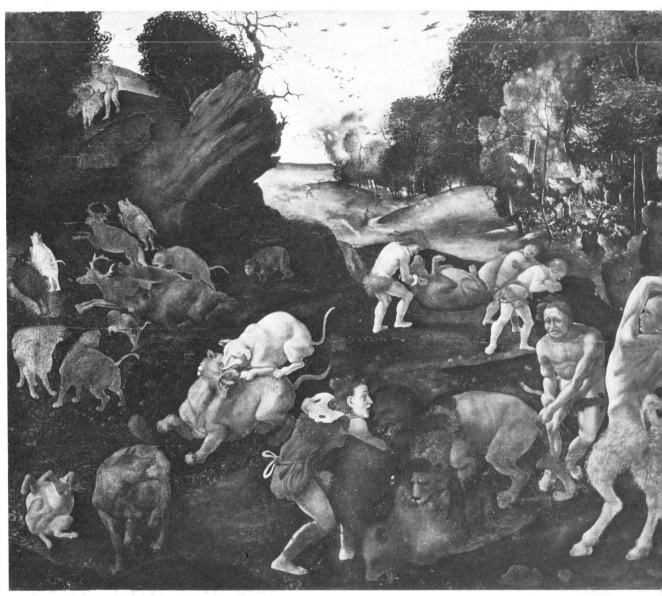

FIGURE 22
Piero di Cosimo, A HUNTING SCENE
Nature at odds with man.

Pleasure derived from "disciplined emotions" is weak at best, and by now, most variants of classicism have been exhausted by endless repetitions; what remains consists for the most part of formalized schemata, trappings devoid of inner life and suggestive power.

There are a few paintings, however, in which the traditional obligation to the classic mode is set aside. An example is *A Hunting Scene* (Figure 22) by Piero di Cosimo, who

was a contemporary of Titian. In his work
classic principles fade in the face of the dia-
bolic. The allure of physical beauty is for
once subordinated, as man and beast are
shown at their worst. The scenery is chaotic,
the landscape is disordered; fires break out in
the woods, the rocks take on turbulent config-
urations—wind sweeps the trees into eerie
shapes—nature is at odds with man. A note of
the bizarre captivates our imagination.

Raphael—David:
The Classic vs. the Pseudoclassic

THE TECHNIQUE OF a painting is revealed in its craftsmanship. Utmost skill and mastery of the painter's craft is evident in Raphael's paintings. His compositions are ingeniously conceived, his colors muted to subtle harmonies. This is admirable, but at the same time it does not arouse our undivided enthusiasm. Small wonder in this era of perfected technology, when a spray gun in the hand of a semi-skilled worker can effect the gentlest tonal transition, such as would have impressed Leonardo himself.

Let us recall that the Renaissance painters were not concerned with being "original," nor did they wish to startle the public with acts of artistic legerdemain; no, the sign of grace was to follow in one's master's footsteps, rather than to disdain tradition. In Raphael's time personal handwriting expressed in the brushwork was not sought after; rather, it was a smooth finish and an almost mechanically perfect paint surface that were admired. Because of these stylistic limitations there is a lack of excitement in the technical aspects of the early Renaissance paintings.

Today, we are indifferent toward the classic muse, but toward the pseudoclassic there is more than mere indifference—there is outright disdain. Consider the 19th century rebirth of the pictorial super-finish—we regard it as insipid. A technique which strives to obliterate the artist's handwriting dulls our sensibilities; patience and assiduousness cannot outmatch verve, meticulousness, keenness of perception; pedantry is not germane to genius.

In David's *Death of Socrates* (Figure 25) (dating from the 19th century) the approach of the painter is pedantic, and by diverting the beholder's attention to a maze of nonessentials, he destroys the coherence of the composition. The slick enameled surface and the hard color render the drama fatuous. In this painting David's proficiency in classic draftsmanship and his professional skill in handling oil paints are of no avail, because here the element of taste is of a very low order. The staging of Socrates' death turns against its director with a vengeance; false sentiment unwittingly creates a mockery of the heroic, and the over-idealization of the characters is pushed to a point where the figures leave the solid ground of reality and become Olympian buffoons.

46

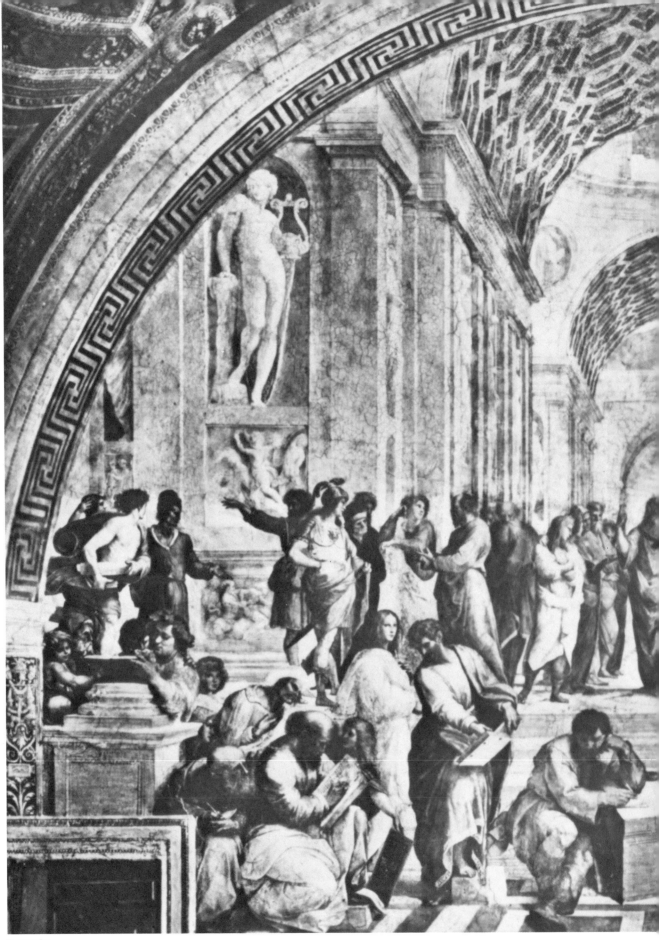

Figure 24
Raphael, School of Athens

48

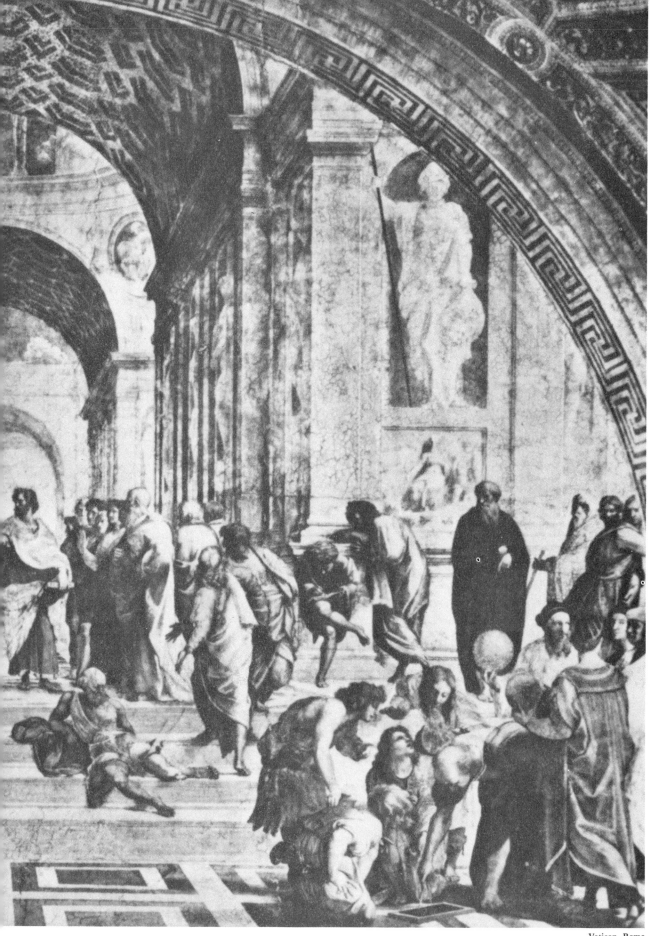

49

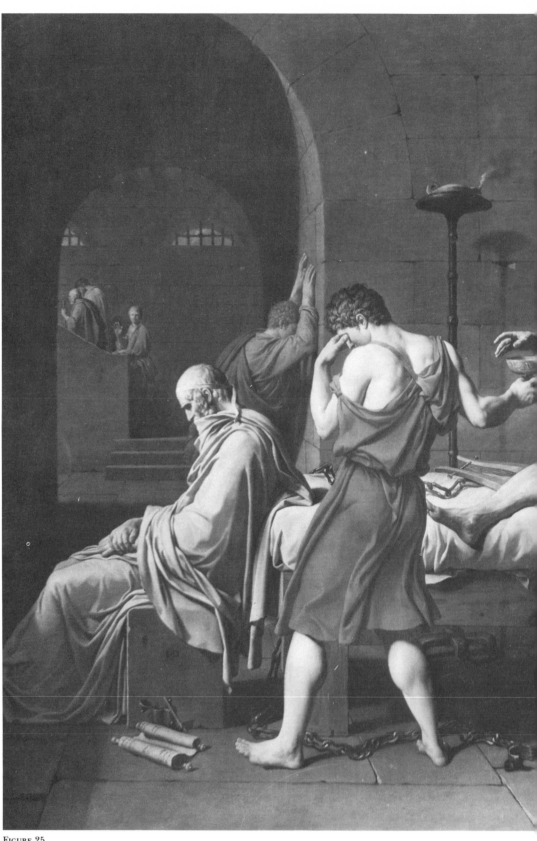

FIGURE 25
Jacques-Louis David, DEATH OF SOCRATES
A congregation of Olympian buffoons.

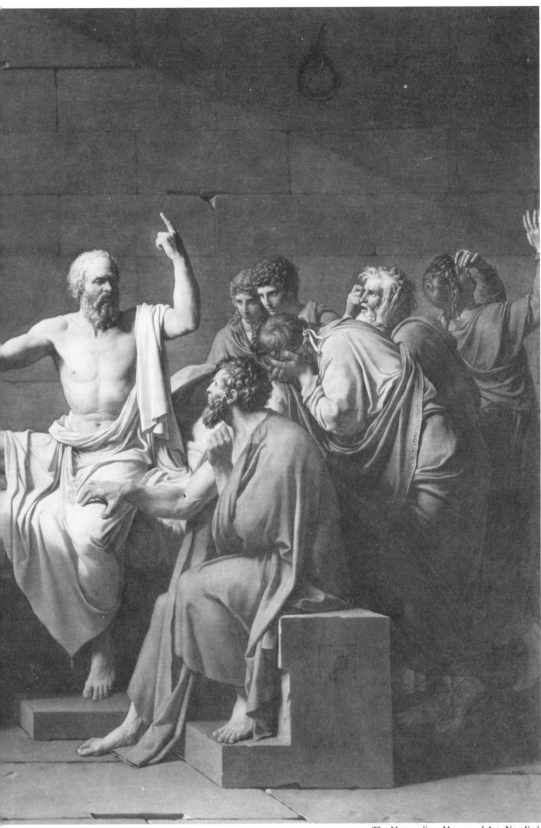

The Metropolitan Museum of Art, New York

51

Guardi—Canaletto:
Venice—The Spirit of Nostalgia

THE INABILITY OF contemporaries to recognize greatness in art as it exists during their time has a long history, and the obverse—the gratuitous veneration of fashionable nonentities has also had a long and dismal run. This is especially true now, when traditional criteria of value have lost currency, and no new standards have been established to replace them. When fashion dictates judgment, thinking loses its elementary function and the condition of connoisseurship can be attained by anyone.

The most significant romantic artist of the 18th century, Francesco Guardi, was held in low esteem by his contemporaries. Joseph Smith, the English consul and the leading art patron of Venice at that time, hardly knew of his existence and thought his work of no importance. There was no Guardi listed in his large collection of paintings. In his memoirs, Casanova mentions that his brother lived in the house of a painter named Guardi—but there is no other comment. Half a century after his death, the art experts referred to Guardi as a "good pupil of Canaletto."

It is doubtful that the power of influencing one's own generation actually demonstrates a painter's importance. History proves that an artist's capacity to attract disciples and imitators during his lifetime does not necessarily indicate his artistic preeminence. It simply shows that he had the good fortune or the ingenuity to arrive at some manner which appealed to the public, and other painters, craving like favor, followed suit. Many a minor painter has exerted a powerful influence on his contemporaries, while the work of some of the foremost masters remained entirely isolated during the period in which they lived. The great precursors of Expressionism, El Greco and Grünewald, are ex-

cellent examples of painters who did not create a school; and Johann Sebastian Bach, one of the greatest composers in history, had no influence whatever on the music or culture of his time. In the eyes of his coevals, Johann Sebastian Bach was "out of keeping with his times, who, in spite of his technical proficency had nothing new to say." Thus, wrote the eminent contemporary music critic, Herr Scheibe.

What makes Guardi's work so eloquent, so much in tune with our own sensibilities? A strange persuasive power emanates from his paintings, issuing from the veiled distances, the light of the declining sun, the long shadows cast upon lonely lagoons. He is the poet of desolate beaches, vast melancholy skies, moldering palaces; the prophet of ruins, the mournful spirit of decline, the conjurer of nostalgic moods, of mysterious darkness creeping into the recesses of decaying mar-

bles, crumbling stones, arches and porticoes, of fleeting light departing from the marshy canals. In his paintings, lost past dreams and an enigmatic presence seeks redemption. The autumn air is burnished by the glinting sun low on the horizon; above the city vistas, the beaches, the sea, and the aimless forlorn figures hovers an illusory haze, a presentiment of the inescapable destiny of man and his work.

This mood is induced in his painting by the staccato display of brush stroke and the muted effects of light and shade; by the melancholy softness of the filtered light as it touches the moist marbles, limp sails and worn pavements of the piazzas before departing foreever from the splendor it illuminates (Figure 26).

Compare the work of Guardi with that of Canaletto, a great favorite of the 18th century British elite—how could one fail to be im-

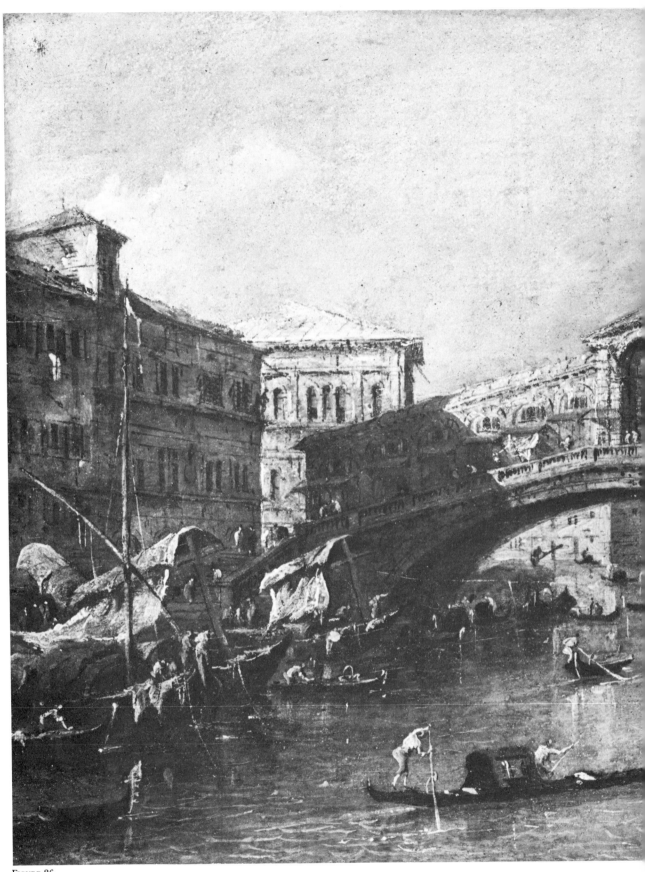

Figure 26
Francesco Guardi, Rialto Bridge
Moods of nostalgia.

54

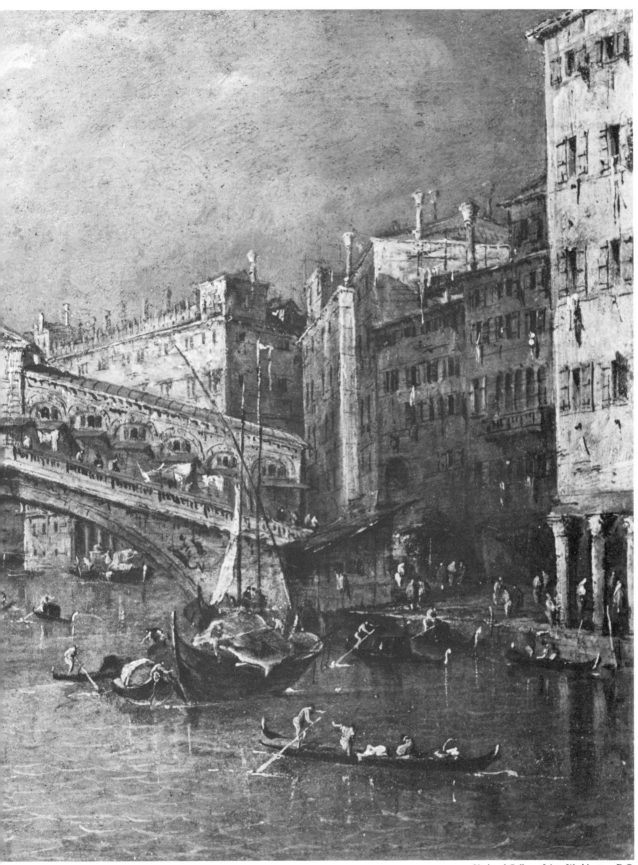

55

Figure 27
Antonio Canaletto, Santa Maria della Salute
A keen eye for the factual.

pressed by the steely perfection of his city vistas? The mastery of his craft is evident in everything he touches; and yet the authenticity of his representations notwithstanding, the elements of sobriety and prosaicism do not reveal the spirit and soul of Venice (Figure 27).

When wandering about the continent in search of beauty, the traveler too often encounters such difficulties that he may no longer be receptive when he finally reaches his goal. When visiting Venice, where enchantment operates consistently in a high register, one need not be intermittently galvanized into self-mesmerization. Places, like works of art, engage our emotions in different ways; antiquities evoke admiration for their aesthetic merit and their style, but few evoke nostalgia. In Venice, nostalgia meets us at every turn — but let us not forget that nostalgia is not a necessarily germane factor in assaying values in the realm of aesthetic.

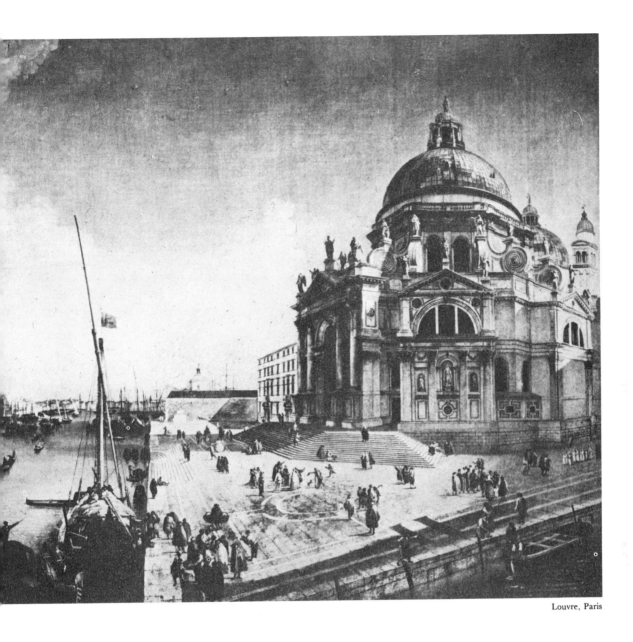

Louvre, Paris

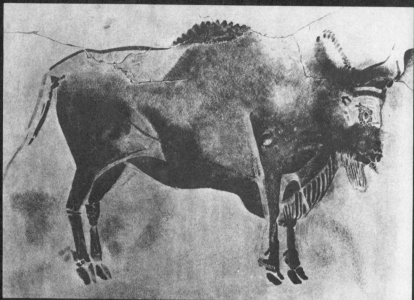

FIGURE 28
BISON OF ALTAMIRA

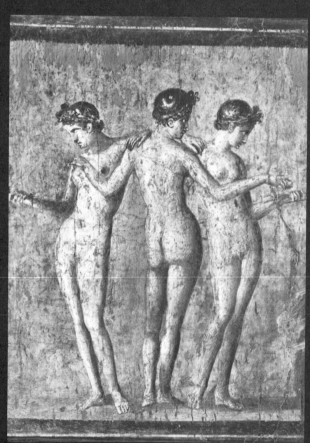

FIGURE 29
POMPEIAN FRESCO

The Evolution of Style

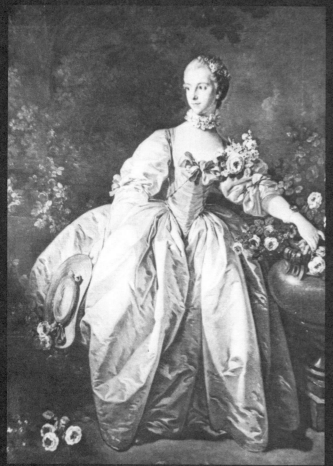

FIGURE 30
Francois Boucher, MADAME BERGERET

Samuel H. Kress Collection

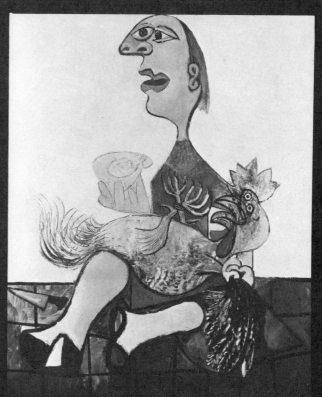

FIGURE 31
Pablo Picasso, GIRL WITH COCK

Museum of Modern Art, New York

Style is the definite, articulate manner in which men express themselves in intellectual as well as artistic activities. The origin of a desire for artistic expression, as involved as it is in the flux of time, lies in man's overt craving to aggrandize and immortalize his person, to glorify his world and his deity, to identify things of his sensual apprehension. In its very essence, style is the way the artist organizes his images. If the age in which he lives offers the artist forms that are ready and perfect for his use, and if the prevailing style is structured to sustain a significant trend, the artist is capable of maintaining a high artistic level.

What criteria of perfection serve us as guides? Formal configurations can hardly be evaluated without reference to their stylistic matrix. In the past, works of minor artists could come near to those of the great, because all of them relied on the same stylistic ideology. The degree of formal perfection, not the kind of conception, was the determining factor. During the time of Johann Sebastian Bach, many a "Schmidt" or a "Müller" composed music that sounds much like that of Bach—but in a "minor key." Mozart's gigantic *Linz Symphony*, composed on commission, could never have been done—as it was—in less than three days if its formal elements had not been available and ready for assembly.

Thus historic styles have played an enormous role in shaping great art. An intriguing thought: had he lived at the time of Mozart,

would Rachmaninoff's vapid compositions have been of greater artistry? Or, if Bouguereau or David had been born in the 15th century, would they have equalled Piero della Francesca or Raphael?

Like everything else, styles wear out; refulgence dims, enchantment turns to boredom, elan becomes routine; on once vernal fields, ashes collect. It is then that the artist meets his greatest impasse. The outworn forms lie in wreckage, quarries are filled with debris, once swiftly moving streams are brimful with silt—the mines are all worked out! In such a predicament, even an artist endowed with the hand of an angel and the eye of an eagle—but the artistic instinct of a fish—will inevitably fail. I am thinking here of the art of the academicians of the French Salon in the late 19th century, who tried to revive the classic mode and failed so dismally.

Style is made by people, yet at the same time it is strangely suprapersonal. The medieval man did not know that he was "Gothic," and the Renaissance man was not aware that he worked in the style of the Renaissance. Incidentally, he also abhorred anything Gothic, and labeled it "contemptible, monstrous, absurd, lacking everything that can be called order," (Vasari), and as often as he could he tried to "modernize" the Gothic edifices unless he was prevented from doing so by the plague, lack of money, or intermittent bellicose enterprises.

Primitive Art

CAN WE SAY, then, that a style came into being with the advent of the Neolithic Age? Hardly, but the Stone Age "artist" produced representations of animals in the caves of Altamira and Lescaux unsurpassed by anything done by "civilized" man. In addition to his power of observation — not rare among gifted artists — by purifying his images of superfluous and burdensome detail, he succeeded in endowing them with ritualistic meaning highly dramatic, authentic and expressive. Curiously, primitive man had no similar faculty for rendering human beings. Perhaps he lacked self-awareness and thus had not developed what we have come to call "ego."

The current predilection for primitive art, and its elevation to a status of special sophistication deserves closer inquiry. To begin with, the collective term *primitive* must be split into categories having one common denominator — a bias against realism. Let us first consider the primitivism of the African and other exotic arts.

It is difficult to apply value judgment when contemplating this kind of work. Evaluation rests on a pragmatic charter, with a built-in paradigm against which an achievement can be measured. But a "perfection" or "imperfection" cannot be measured against another non-classifiable perfection or imperfection. Moreover we are inclined to ascribe to exotic artists special qualities which spring from a "nearness to nature," and impute to

them a sensual apprehension of relationships which are lost to civilized men, but this is speculation unsupported by fact.

The art of the primitives is predicated on nonidentifiable symbolism which lies beyond our comprehension. According to R. G. Collingswood, "As the Greek word indicates, a symbol is something arrived at by agreement and accepted by the parties to the agreement as valid for a certain purpose." This definition clarifies the term sufficiently to abjure the pseudosophisticated prattle of the contemporary "progressives" that has enveloped symbolism in a fog of misinterpretation. In general, a symbol is the concrete shape given to an abstract idea or feeling. These concretions have been made absolute for the purpose of eternalization, and thus have been reduced to a common denominator understood by a group of men linked by the same culture and religion.

In the view of modern psychology, a symbol embodies a conflict between instinctual drives and the moral censorship of the ego. By this definition, a symbol is an ". . . overdetermined image, and its power lies in a seeming inexhaustability of meaning." According to the teachings of psychoanalysis, the mind is a symbol-producing agent, and in dreams it expresses itself almost exclusively in symbols. Regardless of the clinical significance of the psychoanalytic idea of symbolism, it has little artistic relevance. I reject the Freudian asser-

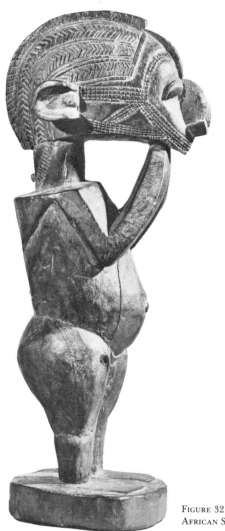

FIGURE 32
AFRICAN SCULPTURE

tion that the art of Western civilization is an expression of unconscious impulses and unadmitted wishes, and that it speaks a symbolic language which operates from all kinds of fixations.

The fashion of dragging modern psychology into the field of art and draping the mental process that generates art in a mythological mantel of obscurity is just what "the doctor ordered—a disguise in which to bury confusion or ignorance. As a result, *symbol* has become the convenient term by which meaningless, cryptographic trivia of all denominations, private imbalance and obscurity are officially sanctioned and solemnized as revelations of "creative genius."

Are we, then, capable of understanding the symbolic meaning of exotic idols? Not in the least; but we are fascinated by the idols, and our imagination is captured by the factor of surprise and the elements of unpredictability and improbability—the subsidiary intoxicants that put our minds in a state of wonder (Figure 32). Escape from the bondage of the familiar, the predictable—the quest for otherness appeals to contemporary man. In exotic art, the anthropometry of the human body is all awry, and the liberties taken with the hu-

man form are the envy of the civilized artist who can seldom use them successfully. Make no mistake: Picasso's venture into the realm of African art produced but inept pastiches of the originals (Figure 33).

The Renaissance man looked with disdain upon the art of the primitives. Shortly before 1400, Filippo Viani wrote in a letter: "Johannes, whose cognomen was Cimabue, by his art and genius first restored verismilitude to an antiquated art that childishly deviated from simulacra of nature because of the ignorance of the painters who were dissolute and wayward." Certainly, the archaic Greek, Byzantine and Romanesque artists—Primitives, as they were then called—worked from exemplars rather than from nature, relying on predetermined patterns and established formulations. Their art, disregarding the "simulacra of nature," fell into codification and became schematic. This is not always a negative assessment; deviation from realism, once considered a failing, has its own, often considerable aesthetic appeal. But the codified systems are deprived of one ingredient—the individuality of the artist—without which, today, the highest attainments in art are rarely encountered.

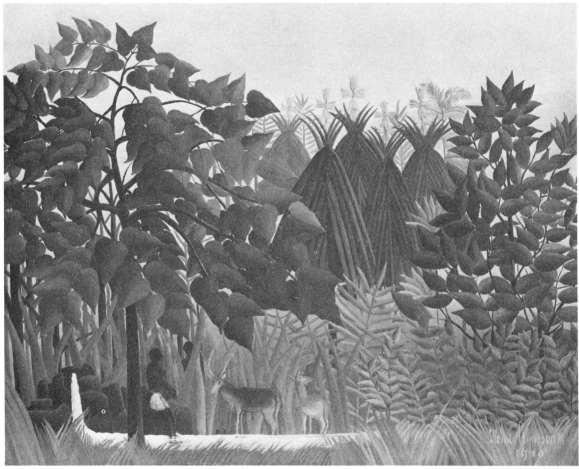

FIGURE 34
Henri Rousseau, THE WATERFALL

Sometimes we refer to a painter as being naive, that is untutored; as a matter of fact, he cannot be tutored. Nevertheless, in certain instances his technical resources can be considerable. Common in a child, true naiveté is rarely found in the adult, who does not share with the child a conceptual manner of visualization. *Conceptual,* as opposed to *perceptual,* implies that the naive painter does not possess the faculty of translating his visual experience in terms of objective realism. He is oblivious of the nature of his own interpretations, and independent of outside influence;

his art is not conditioned by any contemporary or past modes of painting. Characteristically, Henri Rousseau (Figure 34) professed that his chief goal was to emulate the arch-academician Bouguereau (Figure 35). Yet, Rousseau is the greatest of the 19th century naive painters; none of the primitives equalled the subtlety of his poetic imagination and the unsurpassed expressiveness of his color. But—and this must not be forgotten—rarity is a powerful and valued commodity, and true naiveté in a painter is very rare.

And then there is the primitive art of

Figure 35

Nantes Museum, France
William Adolphe Bouguereau, The Birth of Venus

folkloristic complexion—that of European peasantry of the pre-machine age. Unlike the primitive African, the art of the peasant is ornate and festive. It does not express the exigencies of the artist's soul nor his ritualistic obsessions. The measure of his accomplishment lies in the decorative skill of his work.

Because of their inability to perceive and their lack of precision in rendering the factual appearance of objects, there is also considerable allure in the conceptual art of children. Some artists with academic leanings envy the child's naivete and endeavor to emulate his manner of visualization. Generally, a personal approach in the art of a child is not encountered. It seems that the naivete of his art, like that of primitive cultures, cannot be differentiated, and that its style is universal. With the advent of puberty, in most cases, the artistic faculty of the civilized child ceases to exist, and is therefore not a reliable index of his future ability as an artist.

In conclusion, it must be recognized that the term *primitive*, as applied to art, is ambiguous. It was first used within a system committed to upholding the "classic" precepts of art, and hence was born of condescension. Later, modern legislators of taste, by a snobbish inversion, raised primitive art to the realm of the sublime, and included within that context all forms of ostensible ineptitude.

Greek Art
The Golden Age

IT MAY SEEM arbitrary to leap 5000 years from the Neolithic Age to Greece of the 5th century B.C., but in the course of Western Civilization no artistic system of importance appeared in the interval. Western cultures that antedated Greece did not provide the yardstick with which to establish the aesthetic precepts which we have come to call "classic." Protagonists of the mind they were, these Greeks of the Periclean Age. Their avowed faith in reason precluded the worship of statues as gods themselves—their sculptures were instead the formal realization of ideal proportion. Hence, Greek art represents for the first time a reasonable image of the visable world, a triumph of the intellect, and homage to the beauty of man. Realism prevailed through the power of unobstructed observation; harmony was achieved through simplicity, clarity and perfection. These elements established the aesthetic foundation of Western art.

"Dear to me is the bouquet of flowers, and the harp and the dance, and the change in raiment and the warm bath, and love and sleep." So sang Homer, and implicit in his song is the ideal of our own world. Aristotle defined happiness as, "The exercise of vital powers along lines of excellence, in a life affording them scope." Only such an attitude could produce art that today, twenty-five centuries later, stands as a paradigm of all that is beautiful. The essence of this beauty lies inwardly in naturalness, reason and sanity; outwardly it is expressed in the harmony of all parts, each with the other and all with the whole.

In such endeavor, pure structure must prevail in architecture as well as representations of anatomy; hence geometry is the foundation of Greek art. To arrive at the structur-

FIGURE 36
A MODEL OF GREEK ARCHITECTURE
Doric Order

al, form must be liberated from obstructing ornamentation and entangling superfluity—in contrast to the exotic, the Oriental, the slightest irrational tinge or nuance must be eliminated. Even the diabolic is not supernatural and does not permit deformity; extremes of hieratic rigidity and unhampered violence are rejected in favor of a system that postulates simplicity, equability and balance.

Greek architecture is the epitome of simplicity. Essentially it is a post-and-lintel structure topped by entablature and supported by a row of columns. Of all the architectural styles of the past, this is the only one still in use today. (Figure 36).

Greek sculpture of this period, on the other hand, shows a certain limitation. It lacks vitality; even the anatomy of athletes in action seems to have been built over a rigid armature. There can be no doubt that the principles of formalized, anonymous perfection—the tendency toward schematization and the geometric—exclude the possibility of chance or caprice—geometric form does not carry high voltage. The physiognomies of Greek statuary, for example, radiate a chillingly uniform clarity; they all appear to have been cast from the same mold. However, a century later classic containment gave way to a Baroque exuberance not unlike the one that animated our own Baroque style.

True, the bias of our time gives ambiguity precedence over clarity; but it is also true that the mysterious and poetic, the extra-

FIGURE 37
Thorwaldsen Restoration, AEGINA MARBLES

FIGURE 38
Thorwaldsen Restoration AEGINA MARBLES

mundane and portentous are qualities which elevate art—and give it multiplicity of meaning. When beholding Greek sculptures, is it not apparent that the fragments are often more intriguing than the work in its complete state?

Consider, for example, the marble statuary from the Temple of Aphia, found on the small island of Aegina, now in the Glyptothek in Munich (Figures 37 and 38). At the beginning of the 19th century the Aegina Marbles were completely restored by the eminent Swedish sculptor Thorwaldsen; apparently the taste of the Neoclassicists did not run to the fragmentary. Now, however, we feel that these restorations have obscured the true identity of the statuary, and major work was required to

do away with the additions and reduce the sculptures to the fragmented condition in which they were found. Possibly, the fragments conjure up in our imagination a grandeur the original work may never have had.

According to Pausanias, the Greek historian of the second century A.D., it was the custom of the Greek sculptors to use tinted wax to endow the marbles with realistic color. Could we ever admire or appreciate the polychromy of these sculptures? What of Phidias' *pièce de resistance*, the *Pallas Athena,* which once stood in the cella of the Parthenon—a marble colossus bedecked with ivory and golden doodads—a veritable l'art Nouveau creation? Did the Greek sculptor not realize that the polychrome and the monolithic are always at odds? That the chryselephantine Jupiters and victorious athletes were aesthetically offbeat is not a preposterous thought; what could be more odious than to assemble, in

one oval, blonde hair, eyes with enameled whites and lapis-blue irises, and of all things, long eyelashes! (I refer here to the *Delphic Charioteer.*)

To pinpoint the problem, when we consider the probity of a form we shall have to accept the following: since form in its ideal sense postulates monumentality, and since monumentality in its most cogent moments leans toward the monolithic, it is apparent that the more monochromatic the form, the more monumental and unified its effect. It follows that any excrescent elements protruding at odd angles from a solid mass, such as outstretched arms or legs, will appear adventitious and create a feeling of disunity; for as soon as we truncate them and allow just the torso to remain, the solidity of the whole immediately asserts itself. The beauty of the Grecian torso—the aesthetic delight of modern man!

FIGURE 39
THE GODESSES, East Pediment of the Parthenon, Athens
Ah! The inevitability of the rising and falling tide.

70

Roman Art
The Value of Imitation

FIGURE 40
ROMAN SCULPTURE, 1st century A.D. Museo Capitolini, Rome
Dependent on Greek example? Perhaps, but of greater vitality.

AUTHORS OF MOST art history text books regard the Romans disdainfully as "imitators" of Greek art, and assert that Roman artists lacked originality. It is true that the Romans took their cue from the Greek examples; but it is also a fact that the work of these "imitators" possesses internal vitality, variety of attitude and a wealth of imagination rarely found in the art of the Periclean Age (Figure 39). I say *rarely,* for when we consider, for example, Phidias' *Goddesses* from the pediment of the Parthenon, my assertion sounds inaccurate; assuredly, there are exceptions to this rule (Figure 40).

At this point, let us ponder briefly the meaning and import of the quality that has in modern times assumed a dominant role in judging art: originality. Originality was not always desirable, and at one time it would not have occurred to a critic to consider an artist "original" unless he meant it derogatorily. At

certain times, an artist who was original—who deviated from convention—was regarded as a transgressor. The Egyptians put no value on originality; the Greek sculptor up to the age of Pericles lived and worked in anonymity; the Romans concentrated on "imitation" of the Greeks; and the Byzantines felt no need for innovation—in fact, for many centuries their art did not undergo any noticeable change in character and style. The medieval craftsman, creator of those magnificent statues and paintings from the 12th, 13th, and 14th centuries, which today carry the label "anonymous," was not celebrated by his coevals. The superstructure of an all-embracing religious and cultural ideology did not leave the arts freedom to assert their independence and sovereignty. Strangely, some of the greatest works of art originated under an edict that did not allow an artist to express his individuality. Consequently, we are obliged to assume there is little direct connection between the artist's ego and the aesthetic quality of his work.

When art ceased to function as a social force, and with the shift of this function to different cultural levels, the concept of originality came to the fore. In its manifold ramifications, this shift brought about a sea of confusion, culminating in the present day admiration of the so-called "avant-garde." Greatness in art did not necessarily go hand in hand with originality, because in the past, the achievements of original artists were frequently of little aesthetic significance—quite often their originality was achieved at the expense of beauty and skillful execution. In my view, when Giotto, the most original of the medieval artists, left the shelter of the Byzantine tradition, the quality of his art declined. I know that to say this is heresy, and I doubt that such a statement will receive official endorsement.

It is not my intention to disparage the value of originality; my purpose is merely to put it in proper perspective. It is a fact that not one of the greatest contributors to the development of music, for example, could be counted among the ten greatest masters of this art, and to quote the eminent musicologist, De Koven: "...this can be attributed to the fact that the top, top men are primarily concerned with creating great art; they are not concerned with inventing new forms, or treading untraveled paths. The innovators on the other hand, dissipate so much of their energy trying to blaze new trails, that there is not enough, or less left for achieving perfection. Beethoven is a notable exception. Monteverdi, Victoria, Gesualdo and Palestrina are among the most original masters in history, and can by no stretch of the imagination be compared with those three greatest of all imitators: Bach, Handel and Mozart." Indeed, C.P.E. Bach was a more original composer than his father, Johann Sebastian, and the second-rate painters Pontormo, Lorenzo Lotto, and Dosso Dossi greatly exceeded Titian in their originality.

True originality is difficult to assess, for it often assumes many guises and takes on protean forms. Attitudes of eccentricity, minor or major aberrations from the "norm," inverted platitudes, freakish deviations are today accepted as manifestations of original conceptions. It is the inability of the critic to distinguish true achievement from the bogus that has created havoc and corrupted the public's understanding of art values. True originality

FIGURE 41
ROMAN PORTRAIT HEADS
First successful realistic representation of human physiognomies.

can be apprehended only when viewed from a historical perspective.

Roman art, then, is not the work of celebrated masters, and few names in Roman sculpture have come down to us. Most of the effigies were done by anonymous stone cutters who produced works of the highest artistic quality. This is especially true in representation of characters—in portraiture (Figure 41). Although one is tempted to say that Roman naturalism of this genre is "photographic," it is quite different from the naturalistic approach found in any other period. By the strange alchemy of "style," the sculptors endowed their portraits with a formal design which, transcending photographic likeness, resulted in a reinterpretation of fact into a specific Roman equivalent.

All classic architecture produced in our time is totally dependent on Roman invention. Although the Etruscans were the first in Europe to employ vaults in their buildings, the ingenuity and technical prowess with which the Romans constructed their majestic arches, vaults, and domes has never been surpassed. They retained the Greek orders— Doric, Ionic, and Corinthian—and endowed them with luxuriant surface ornamentation, giving them a splendor that formed the basis of all Renaissance palace architecture. Mention should also be made of the Roman murals in the villas of Pompeii and Herculaneum, which are distinguished by the same high degree of refinement and sophistication.

73

Byzantine and Romanesque Art
Anti-Realism

STYLE IN ART represents a specific version of the world; hence, if we are not conversant with the form language of each style, comprehension of art in all its manifestations is impossible. The art of Byzantium remained unchanged over many centuries—a phenomenon explained by Byzantine political and social history. Part Oriental, part Roman, but different from both in its particulars, it was essentially the art of the Christian church. Because of the hieratic character and high degree of stylization of Byzantine art, the Byzantine artist—or, rather, craftsman, for art had not as yet assumed an autonomous function—was allowed to use all manner of decoration, conditioning of forms, and a coloristic splendor germane only to anti-realistic conceptions.

Byzantine painting was limited to small panels serving devotional purposes—the so-called ikons. The glory of Byzantine art, however, expressed itself in mosaic (Figure 42). Unlike the Roman mosaics, which were predominantly monochromatic, the Byzantines covered large wall surfaces with multicolored tesserae. They were made of tinted glass and gold foil incorporated into a semi-liquid glass surface. Like mirrors, the little squares reflect light in the dim churches, and the varying angles of their surfaces produce incomparable effects of brilliance and texture.

The Byzantine mosaics are exquisite, but this art loses its aesthetic appeal in later epochs. For example, the 15th century lunettes over the doorways of St. Mark's in Venice are much less interesting than those of the 12th and 13th centuries, and those in the Baroque style of the 17th century are rather ungainly. And what of the small bronzes, the fantastic animal effigies? Only the Byzantines could produce objects of such visual enchantment. The earliest examples of figural and ornamental sculpture come from sarcophagi, probably carved in Asia Minor. They have Roman traits, but the ornamentation is distinctly Oriental, especially in the proliferation of vine designs, which came from Mesopotamia.

Figure 42
Mosaic
Hieratic splendor.

Palatine Chapel, Palermo

When we consider the exterior of Byzantine architecture, however, the picture is rather bleak. The basilica, with its vaults and domes came from Rome; also from Rome came the resplendent multicolored marble veneers used to encrust the interior walls and the polished monolithic columns.

Historic styles often merge in a broad confluence that defies precise dating. Thus, during the greater part of the 13th century, Byzantine and Romanesque styles coexisted with minor differences between them. Unlike the Byzantine, the Romanesque style did not favor painting. Romanesque art expressed itself instead in sculpture, stained glass, illuminated manuscripts, enamel, carved ivory and decorative objects forged from gold and silver. As long as painting remained within the Byzantine tradition, its decorative appeal is very great; however, any attempt at verismilitude—as in murals—resulted in crudeness.

Boundless fantasy and audacity distinguish Romanesque sculpture. These qualities

created a wealth of images—monsters, goblins, angels and devils, grotesques of all kinds—and these appear very real, for the iconography of medieval man was not a trumped-up whimsy, but the expression of his particular imagery. Unhampered by obligation to realistic representation, the anonymous stone carvers, (Giselbertus, the master of the Cathedral of Autun is among the few exceptions), charged their creations with a furious vitality and imagination rarely achieved elsewhere in history (Figures 43, 44)

Romanesque architecture, by which these predominantly monastic structures can be identified, is characterized by heavily built walls with external buttressing, flat and plain interiors, small windows, and rounded arches. The western facade is often arranged in graceful gabled porches, arches with clustered piers, and door shafts with heavy carved moldings (Figure 45). In many instances the facade is adorned with elegant blind arcades, colonnettes, and pilasters. A charming detail

75

FIGURE 43
SCULPTURE FROM CHARTRES CATHEDRAL
Boundless imagination and audacity.

of Romanesque decor is the columns which rest on the backs of fierce-looking animals—lions and monsters. Sights of endless delight, they are found in doorways and pulpits. The ceilings of the churches are sometimes barrel-vaulted, often constructed of ribbed groin-vaults. Elaborately carved leaf, geometric, and grotesque ornaments are used extensively on the capitals of the columns in the door-ways, corbels, and moldings, and stern hieratic figures grace the wall, niches, portals, and tympanums of the churches.

Mention should also be made of the resplendent work of the 13th century Cosmatic School, which derives its name from the family of renowned marble workers. The Cos-

mati technique employs small particles of precious marble, porphyry, and other colorful stones, arranged to form meandering ornamental bands, and generally referred to as "opus Alexandrium," or parcel mosaics. Occasionally such ornamentation is used even on large surfaces. The best example is the facade of the cathedral in Orvieto.

In the preceding pages I have made ample reference to decorative expositions which, in my view, should be considered expressions of a supreme creative endeavor equal to the best art we see framed and hung on the wall or placed on a pedestal. The German word for decorative art is *Gebrauchskunst,* in literal translation "applied art"—art applied for a

FIGURE 44
SCULPTURE FROM CHARTRES CATHEDRAL

FIGURE 45
SAINT SEBASTIAN CHURCH, 13th century
Still quite austere.

certain purpose—whereas "creative art" is supposed to serve for art's sake, as implied by the French expression *l'art pour l'art*. During the medieval age, when religion was universally accepted, when it united and controlled all spheres of individual and social life, no dichotomy between these conceptions existed, for art served the practical purpose of illustrating ecclesiastic themes, and sumptuous ornament was the high point of its artistry. In fact, ornamental designs created during the Carolingian and Romanesque eras (8th to 13th centuries) are unsurpassed in their creative imagination and complexity.

77

Gothic Art
Christian Faith Exalted

THE TERM *Gothic* APPEARED for the first time in Italy during the Renaissance, when it was erroneously assumed that the buildings of the Middle Ages were the work of the Goths who overthrew the Roman Empire. Because of this association, Gothic was a derogatory term that meant "barbaric." In France, where Gothic art first appeared in the 12th century, the style was referred to as *Opus Francigenum.* It spread rapidly throughout Europe and, depending on its geographic location, lasted from about 1200 to 1550. Thus Gothic first merged with Romanesque and later coexisted with Renaissance and even Baroque. In fact, in England the Gothic style has never gone entirely out of existence. Because of its long duration, there are definite variants of the style, referred to as Early, Middle, and Late or Flamboyant Gothic. The Gothic style developed logically and organically from the preceding Romanesque. Romanesque elements of form—elongation of the human body, rigid stance, and rounded arrangement of folds—still prevail in early Gothic art. Later, a characteristically mannered angularity of folds is standard; this style is referred to as "harte gothic" (hard gothic) (Figure 46).

Almost till the advent of the Renaissance, Gothic painting in Italy—particularly in Sienna—was heavily influenced by the Byzantine style of the ikons. But the most perfect configurations of Gothic painting were developed in Flanders. Northern Gothic art is distinguished by stark realism, and lasts well into the 16th century. The most striking quality of Gothic painting is the consummate craftsmanship—the clear, brilliant jewel-like colors and the technical mastery of execution. These qualities have seldom been equaled in the history of art (Figure 47).

Gothic builders borrowed the rib vault

FIGURE 46 Gothic sculpture, 16th century
Tilman Riemenschneider, SAINT JOHN
Western civilization gave us two great epochs of sculpture: the Greco-Roman and the Gothic.

78

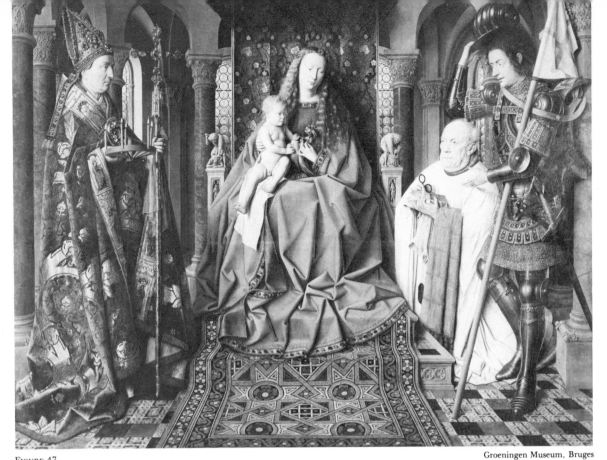

FIGURE 47
Jan Van Eyck, ADORATION OF THE MADONNA
Unsurpassed technical mastery, miniaturization of large forms
without impoverishing them.

FIGURE 48
CATHEDRAL OF MILAN 14th century
The miracle of faith—craftsmanship and imagination.

from the Romanesque prototype, and invented the ogive (pointed) arch and window and the flying buttress. This is perhaps an oversimplification, but the entire development of Gothic style depended on these innovations, for they transformed the solid enclosure into one that may best be called "skeletal" (Figure 48). The introduction of flying buttresses, which resist the outward thrust of the vaulting, obviated the extensive use of walls for structural support, thus creating the possibility of almost unlimited window space. The ogive is the hallmark of the style; it is applied to pier arches, doorways, and windows. The windows, made of stained glass, became ever larger in size, requiring more complex tracery. To dramatize the upward surge, the engaged columns of the piers often reached to the vaulted ceiling, which itself was now an important part of architectural decoration. The ceiling consisted of independent ribs; the intersection of the ribs was adorned with an elaborately carved ornamental block called a *boss,* which added richness and unity to the whole.

Renaissance
Humanism Glorified

THE RENAISSANCE DATES from the beginning of the 15th to the end of the 16th century, and can be divided into three characteristic phases: Early, High, and Late Renaissance — the latter also referred to as Mannerism. The art of the late 14th century period of transition retained some Gothic traits, and the Renaissance style emerged in its pure form in Italy — most notably in Rome and Milano — with the start of the 15th century. The Gothic masters had dealt with humanism, but they subordinated it to religious force; the glory of their paintings belonged to Christ. In contrast, Renaissance artists drew from the elements of classic style and cast their pictorial images in an aesthetic formula that transcends man's inherent fragility.

Early Renaissance style is characterized by simplicity of form and solemnity of attitude, both analogous to the classic style of the Periclean Age in Greece. Compositions were constructed along frontal planes and stratified in depth on horizontal and vertical axes. The contours of objects lost some of their rigidity, so the objects were no longer isolated from their surroundings. Polychromy, the mainstay of the Gothic painting, was no longer sought, and emphasis on tonal rather than on stridency of color asserted itself. (Figure 49).

One innovation that distinguished 15th century painting from that of earlier periods is the use of chiaroscuro — the interplay of light and shadow. Employed at first with a certain restraint, the dramatic possibilities of chiaroscuro were consciously exploited in the High Renaissance around 1500, and Leonardo da Vinci became the most eloquent exponent of this system.

The High Renaissance developed forms of greater complexity, with stress on rich surface ornamentation similar to that of ancient Rome. Mannerism appeared during the post-Leonardo period, about the middle of the 16th century. This last phase of Renaissance art was characterized by a decline, a deterioration of those stylistic qualities that had distinguished the earlier periods. It would

FIGURE 49 National Gallery, London
Piero della Francesca, BAPTISM OF CHRIST
Serene, monumental.

seem that after Leonardo, all mines were worked out, and the artists, in a frantic search for innovation, steeped themselves in all manner of exaggeration and affectation — indeed, Mannerism — in its extreme form — harbors traits of hysteria! El Greco is the most characteristic example of a Mannerist artist, but — "quot licet Iovi, non licet bovi," (what befits Jupiter is not befitting a bull.) El Greco was a man of genius — he could make a virtue even of affectation.

To capsulize the forces that shaped the Renaissance's *Sturm und Drang,* (Storm and Stress) we could say that in the main it grew to its height through the discovery of two nutrients: scientific or, more accurately, empirical perspective, and the anatomy of the human body (Figure 50). Certain discoveries

80

FIGURE 50

Rafael, FIGURE DRAWINGS

The rediscovery of anatomy of the human body

take place at a particular stage of development; some styles favor architecture, some sculpture, some painting. The Renaissance gave its artists an aesthetic system eminently suitable to bring all these disciplines to their absolute height.

Renaissance sculpture was patterned after classic Greek style, inasmuch as it sought "ideal" rather than realistic images (Figure 51). Yet these ideal aspects were different from those of 5th century Greek art, for the Renaissance sculptor was concerned with the representation of humanized attitudes rather than with formalization of the human body. Closer observation of natural appearance, modified by idealized features and heroic overtones, is characteristic of 15th and 16th century sculpture. Like painting, early Renaissance sculpture stressed the frontal view; it favored the wall, and never quite freed itself from it—it remained part of architecture. In consequence it must be seen largely by its outlines or contours, for we are dealing here with isolated "closed" forms.

Renaissance architecture gave the Western world a style that endured into the 20th century. The source of inspiration for the builders was Roman architecture. Roman principles, however, were not imitated, but rather developed and most ingeniously utilized. Renaissance architecture, lacking the originality of the Gothic style, was not ideal for church architecture, although the lantern-crowned dome placed on a high drum has become the most impressive feature of the cathedrals. Rather, it favored palaces, villas, and municipal buildings. We may divide the style of architecture into three phases: approximate dates are 1400—1450, 1450—1500, and 1500—1550.

Early Renaissance architecture is recognizable by the simplicity and austerity of the facade; all its expositions are close to the wall and none of them appear to extend beyond the surface of the building. The composition of the facade—the structure's string courses, its fenestration—is such that only the frontal view gives us a clue to its design (Figure 52). The first stories of the earliest buildings are heavily rusticated with strong corner quoins, which add to the severity of their fortress-like appearance; there are few decorative embellishments to soften the stern look, but harmony is maintained by the proper relationship between the stories and their fenestrations within the wall space. Palaces belonging to this category, all of which are located in Florence, are the Pitti, built by Brunelleschi, and the Medici-Riccardi, built by Michelozzo. An example of more advanced design is the Rucellai Palace, designed by Alberti; here the architect produced vertical accents by arranging pilasters in superposed stages. Its rustication is more flattened and delicate than usual. Because builders were generally restricted in exterior design, they constructed interior courts graced by columnar arcades, in the style of medieval monasteries. The simplicity of the early Renaissance style gradually gave way to luxuriance; Roman ornamental details were often copied; fanciful moldings and pilasters covered with arabesque patterns appeared. Interiors were adorned with marble inlays, terra cotta and stucco work, and the ceilings became veritable riots of sculptured and painted decoration.

FIGURE 51
Donatello, SAINT GEORGE
Ideal, yet human.

FIGURE 52
EARLY RENAISSANCE FACADE
No longer the front of a fortress.

Baroque
The Age of Magniloquence

THE TERM *Baroque* IMPLIES irregularity and contortion, and has often been used as a pejorative to denote clumsy, florid forms. The style was considered by many a degeneration of Renaissance art; but this notion is manifestly false, for the two rest on diametrically opposite premises. In Italy, the Baroque style reached its mature configurations after the middle of the 16th century, and lasted well into the 18th century; in other parts of Europe it matured later by half a century or more. It gave the most powerful expression to architecture, less to sculpture, and on the whole it did not especially favor painting, although a few painters of great genius lived during that period.

The guiding principles of Renaissance art are clarity of exposition, observance of empirical perspective and the use of firmly articulated contours. In Baroque art none of this applies. Instead, ambiguity and concealment prevail, and vaguely defined contours are the rule. The swirling movements of the Baroque change the horizontal and vertical into diagonals and the planimetric into the recessive; it blows drift and turbulence into the static form, and prevents the objects from being solidified within definite silhouettes. Its overcharged composition transforms tranquility into restlessness, reticence into theatrical magniloquence (Figures 53, 54, 55). The use of chiaroscuro is intensified, and its application distorted. No longer do light and shade serve to clarify the form; instead they obscure it, charging the scene with ambiguity. The most dramatic manifestation of this pictorial system is present in the work of Tintoretto. (Figure 56).

The same method rules the configuration of Baroque sculpture, which partakes of tone rather than of line. Its contours have been depreciated and its solidification within given boundaries impaired. By pulling the forms apart, recessions and protrusions are created; these catch light and receive or cast shadows, thus depriving the figure of its substance and rendering it pictorial rather than sculptural.

FIGURE 53
Peter Paul Rubens, GOLGATHA
Here all is adrift and in turbulence.

Staaten Museum, Copenhagen

FIGURE 54
Titian, THE ASSUMPTION

Basilica, S.M. Gloriosa Dei Frairi, Venice

The Metropolitan Museum of Art, New York

FIGURE 55
Titian, VENUS AND ADONIS (Detail)

FIGURE 56
Tintoretto, CHRIST AT THE SEA OF GALILEE

89

Sculpture is no longer static, but in flux. Strangely, the art of Bernini, the Baroque sculptor *par excellence* — particularly in such works as *Apollo and Daphne* and the *Rape of Proserpina* (Figure 57) (both in Palazzo Borghese in Rome) — is reminiscent of Victorian kitsch (poor taste).

In the works of the 19th century writers, we find references to Baroque architecture that read: "lawless and tasteless," "debasement of the classic architectural form," "pretentious sham," all of which point to the lack of recognition of the principles that make Baroque a style that does not conform to the precepts of the orthodox classic aesthetic (Figure 58). Hence, negative verdicts such as "broken and contorted pediments," "huge scrolls," "heavy molding," "sculptures in exaggerated attitudes" do not constitute a depreciation. Liberated from the flatness of the facade, porches and loggias sprang up on buildings. Rustication was confined to basements and corner quoins, once engaged columns and pilasters detached themselves from the walls, adding greater depth and imparting variety to the effects of light and shade. Broken pediments and exquisite enframments appeared over doors and windows. The interiors, too, were embellished by convoluted columns with stuccoed capitals; wood was painted to imitate marble, moldings and cornices of elaborate design were richly decorated; sculptural lunettes and ceilings of incredible sumptuousness were constructed — indeed, Baroque architecture harbors traits of megalomania (Figure 59)!

Regardless of the angle from which one views these edifices, the pictorial quality expressed in the variety and irregularity of the total effect is fully revealed — and this variety and irregularity is the very core of the style. It must be also understood that the major decorative elements in Baroque architecture are not extrinsically attached embellishments, but are in essence intrinsic parts and subdivisions of the larger architectural scheme.

FIGURE 58
BAROQUE CHURCH
Quite pictorial in its effect of light and shade.

Catania, Sicily

FIGURE 57
Gianlorenzo Bernini, RAPE OF PROSERPINE

91

FIGURE 59
BAROQUE INTERIOR,
Scuola Grand di San Rocco,
La Grade Sala, Venice

92

Rococo
The Style of the Affluent Society

DURING THE SECOND half of the 18th century the forces that initiated the Baroque with a fanfare wore themselves out; now the sounds, taken up by fragile flutes, turned vibrato. The melodies, precious and genteel, decked themselves in frilly cadenzas and exquisitely elegant, extrinsic decor, became the *dernier cri* of the day. The style thus configured is known as Rococo. In painting, it is the art of the salons—vapid portraiture and jollifications indulged in by the "idle rich" of the court is its predominant theme. Porcelain figurines, faience, and bric-a-brac were the chief sculptural products of that era (Figures 60 and 61). Of course, as in most declining art systems, some artists—Watteau, Chardin, and Guardi, among others—produced works of great artistic merit during the Rococo period. Rococo architects were not innovative; instead they deprived the Baroque ornaments of their ponderousness and massiveness, and reduced its forms to extrinsic convolutes, graceful and eminently suited for interior decoration (Figure 62).

With the demise of Rococo the probity of all traditional ornamentation took a steep decline, and with the advent of the machine age decorative art lost its *raison d'etre,* for the machine abjures all expositions serving other than functional purposes. Its ideology is rooted in function, and function alone—it is not given to sentimental intervention.

FIGURE 62
ROCOCO INTERIOR
Exquisitely elegant.
Palazzo Razzonico, Venice

94

FIGURE 60
ROCOCO FIGURINE, After 1750

FIGURE 61
ROCOCO FIGURINE,
The Metropolitan Museum of Art, New York

Neoclassic Revival
The Failure of Imitation

WITH THE PASSING of Louis XVI, the style of the Rococo became defunct and the artists of the Napoleinic age felt compelled to imitate classic forms; they created hard-edged images tinted with brittle, glassy colors and compositions full of specious rhetoric — their heroic effort to resuscitate the grand manner of Raphael proved futile. Neoclassic sculptors produced pastiches of ludicrous character — the climate of the Napoleonic era had nothing in common with either the Periclean age or that of Donatello. Curiously, though, Canova, who was the foremost exponent of Neoclassic sculpture (Figure 63), must have understood Greek art very well — theoretically for when he was asked by Lord Elgin to restore the Parthenon Marbles, he said: "It would be sacrilege to presume to touch them with a chisel."

Even during a time of general disorientation in the realm of aesthetics, some works of considerable merit are created. Consider Ingres, for example: when he chose simple subject matter, his paintings, though somehow glassy and frigid, have great beauty (Figure 64). Neoclassic landscape painting, because of its pervading mood of serenity and excellent craftsmanship, also possesses particular charm.

FIGURE
Antonio Canov
PERSEUS HOLDING THE HEAD OF MEDU

96

FIGURE 64
Jean-Auguste Ingres, ODALISQUE IN GRISAILLE
Glacial perfection.

99

Art of the Victorian Age
Merits and Demerits of Eclecticism

THE TERM VICTORIAN, if not entirely accurate, is very convenient. We are concerned here with works created following the Empire period (Regency in England), up to the advent of Impressionism. The Neoclassic—Napoleonic and post-Napoleonic—style was the last one guided by a suprapersonal ideology. By the middle of the 19th century Neoclassicism became obsolete, and the mode of painting which followed is now classified as "Romantic." Romantic painters—or, perhaps more accurately, the pre-Impressionists—no longer unified by tradition, went their own individual ways. Among them were Corot, Delacroix, Courbet, Degas and Manet. In contrast to the academicians of that period—those who believed themselves to be the inheritors of tradition—these artists were greatly concerned with technique, with the effects produced by brush stroke, texture and contour. They possessed originality in varying degrees. The academicians, on the other hand, addressed themselves almost exclusively to the illustration of anecdotes, history, mythology and religious themes, and their aesthetic approach remained impersonal. Now, originality should not be equated with the characteristic traits displayed by a particular painter which allows us to identify his

work, for such distinguishing traits can be found in pictures produced by the most insignificant academicians.

Corot's early Italian landscapes attest to the fact that he was a great painter. His contemporaries, of course, did not think so; they admired the feathery landscapes reminiscent of the school of Ruisdael, which were then very much in vogue. However, the word "reminiscent" does not necessarily carry a negative connotation. The degree of dependence on an earlier style may or may not invalidate a painter's work—Corot's reminiscences produced some exquisite paintings (Figure 65).

In evaluating Delacroix's artistry, we are faced with a dilemma. His native talent expressed in portraits is comparable to that of Goya. Indeed, he possessed more élan and verve than any other painter of his age. But alas, he was not conscious of the fact, or perhaps because of his facility, he did not realize that theatricality and exoticism could not be digested pictorially, at least not in his time. Here, a great talent went to waste depicting Algerian seraglios, Sardanapalus' feasts, and spectacles of similar nature (Figure 66). Many of the most skillful practitioners of 19th century genre painting fell victim to the same fate.

Courbet was a "frank" realist, and his

FIGURE 65
Camille Corot, LANDSCAPE WITH THE COLISEUM
Neo-classic simplicity.

FIGURE 66
Eugène Delacroix, *Massacre at Chios* (Detail)
Cinematic subject matter; too rich for pictorialization—19th
century style.

outlook greatly offended his contemporaries.
His figural pieces were very much to the
point—there was no divergence here from the
"facts." But, oh, strange alchemy of art, facts
are not necessarily factual. In his landscapes,
factuality has gone through the meander of
the painter's sensibilities to create images that
have faint similarity to the actual objects, and
these are his best. If the waves in his seascapes
are not exactly "real" waves, they are more
convincing than the realistic seascapes seen on
calendars (Figure 67).

FIGURE 67
Gustave Courbet, BEACH IN NORMANDY

Figure 68
Eduoard Manet, Bar at Folies Bergère
Painterliness exalted.

Manet was a "painter's painter," but as he studied the art of Goya and Velazquez he came to rely on them quite heavily. However, he fell short of the quality of his preceptors, because he did not have the background of stylistic ideology that governed the artistic processes of his predecessors. In certain instances; he attained a very high level of artistry (Figure 68), but when he attempted modernism of the Impressionistic persuasion, his native faculties floundered in the *mare tenebrarum* (sea of darkness) of unassimilated ideas.

Degas is the most outstanding artist of his generation. His system of composition, aided by low-key colors, is of unsurpassed originality (Figure 69). The colorful and often beautiful pastels of his late period, which receive the highest critical acclaim are, in my opinion, of less importance, as are his bronze figurines. Such a weighty material as bronze cannot be used successfully to represent scenes of the genre. The famous dancer dressed in tutu — cannot that sculpture be regarded as Pop-Art a hundred years ahead of its time?

As to the official Academy, works of some of the leading painters once acclaimed as descendants of the great masters clearly demonstrates the debasement of academic art that ruled the large exhibition premises of the

FIGURE 69
Edgar Degas, THE MILLINERY SHOP
Original and unerring sense of composition.

French Salon (Figure 70). Here, false senti-
mentality, ludicrous pathos, and oblique
references to a tabooed sexuality abound.
Nearly all academicians displayed, in various
degrees, poor taste and the lack of under-
standing of principles of good composition.
Despite their expert draftsmanship, which was
sometimes combined with considerable paint-
erly gift, (as with Meissonier), these painters
are in most cases what we would call illustra-
tors. Paradoxically, in spite of the accurate
detail of architecture, accouterment and cos-
tume, the scenes played by the actors in their
paintings appear to be poorly directed and fa-
tuous in their demeanor. It is said, for exam-
ple, that before Meissonier painted a battle
scene he would have a herd of horses trample
the fields so he could study the effects of the
ensuing devastation.

Few paintings of this period deal with
religious subject matter and those which do
fail in their authenticity. When the Old Mas-
ters painted biblical or historical themes they

FIGURE 70
Pierre Auguste Cot, THE STORM
Coy, sentimental, very false.

FIGURE 71
Jean-Baptiste Carpeaux, UGOLINO AND HIS SONS
A travesty of the classic style.

The Metropolitan Museum of Art, New York

used the costumes and trappings of their own time, and this because history was not yet a subject of ethnological, that is scientific, research.

Victorian sculpture borders on the ludicrous (Figure 71). This includes some of the work of Rodin, although his portraits and some figural sculptures such as *The Burghers of Calais* and *St. John* are authentic masterpieces created in the best neo-Baroque tradition, these are not merely sentimental inanities or pointless derivations of the classic mode.

The stylistic configurations of Victorian architecture represent a pastiche, a mixture of undigested influences from the past; however, the term "pastiche," by its definition (borrowing from other styles), does not always carry a negative assessment. If we put all doctrines aside and visualize from a non-purist viewpoint, even a combination of styles can, at times, be aesthetically acceptable. Consider, for example, the Opera House in Vienna,

Austria, built in 1862. Here Neoclassic, Byzantine, Romanesque, and Gothic traits are combined to form a most impressive Victorian edifice. The same can be said of the Opera House in Paris, erected in 1857 during the second Empire. Its neo-Baroque style, in spite of its irrelevant external decorations, is just right for the occasion. And what of the architectural folly of the *fin de siècle* (end of the century) style seen in the entrances to the Parisian metros? Because of their particular locale, they must be regarded as a forgivable caprice. The same is true of the neo-Gothic American country homes, and homes erected in the so-called Federal style—even if we concede that in such instances our acceptance is guided by sentiment and nostalgia rather than by traditional formal considerations of style. On the whole, however, when architecture of that period does not use extreme discretion in the manipulation of older traditions, it borders on the absurd.

106

The Achievements of Impressionism

Frick Collection

FIGURE 72
Claude Monet, VETHUIL IN WINTER
Literal representation of topical motives.

DURING THE LAST quarter of the 19th century a group of painters, who were endowed with more audacity than genius, decided that they had "had it." Disdainful of tradition, rejected by the Salon, and disgusted by the insipid genre and historical potboilers, (the execution of which required rigorous academic training which they did not possess), they initiated a movement which has been labeled Impressionism (Figure 72).

Radically repudiating the "tobacco juice" colors of the conservatives, the Impressionists carried their easels into the open and introduced colors associated with sunlight. In addition, they divested their motifs of the pernicious entanglement of superfluous detail—the miasma of irrelevancy, the debauch of senti-

mentality in which the painters of the Salon indulged.

But it must be said that, on the whole, the work of the Impressionists is marred by sobriety and prosaicism, and that their attempt at rendering brilliant sunlight effects proved to be futile. Colors as they appear in the light spectrum cannot be imitated by using oil paints. Besides, it is feasible to paint out of doors only when working *alla prima,* as did Cézanne and Van Gogh. When painting out of doors, for example, Monet placed himself in front of a haystack at 10 A.M.; at 12 noon, when the light changed, a new canvas was taken; and at 2 P.M. and 5 P.M. the process was repeated. However, since the original alla prima work appeared to be unsatis-

107

FIGURE 73
Pierre Auguste Renoir, THE BOATING PARTY
Pictorial prowess following a great tradition.

Phillips Memorial Gallery,
National Gallery of Art, Washington, D.C.

factory, more paint was daubed on the canvas in the studio. Considering the nature and quality of the paint used at that time, the final effect resulted not in brilliance, but rather in a lowering of the key of almost all colors. The introduction of violets, purples, mauve, and related hues produced not only disagreeable optical effects, but destroyed the unity and solidity of the paintings. Not all paintings by the Impressionists carry such characteristics; but such were, in the main, the principles governing orthodox Impressionism. However, the "revolutionary" imperative of the movement remained incomplete, for in spite of its ostensible modernism, the system clung to tradition dictated by the well-aged laws of atmospheric perspective. It remained for Cézanne to make the final break. Today, the works of the Impressionists are the much-sought-after articles of conspicuous consumption, and it is unlikely they will receive a negative critical assessment.

A special case should be made of the art of Renoir, for his version of Impressionism differs radically from that of Monet and others. Because of his early training as a porcelain painter, he was familiar with the processes of glazing, which immensely enlarged his repertory of technical resources. His early work is of great excellence (Figure 73). We arrive at this value judgment by examining the quality of his painterly approach—the character of his brush work, the resonance of his colors. Within the framework of his time, his artistic potential reached its ultimate height. But, when he was in his middle years, his faculties became depleted, his colors turned acidy, his imagination atrophied. Later, he was crippled by arthritis and had to work with the brush strapped to his hand. As his disability progressed, his one time great talent vanished. Predictably, the experts and the art trade totally ignore this circumstance.

108

The Cézanne Mythos

CÉZANNE IS JUSTLY called the "father of modern art." In many circles, his name is mentioned with a reverence formerly reserved for saints. In a typical synthetic eulogy the critic J. Fitzsimmons writes: "But impressionistic color was not solid enough for him; he intensified it, condensing light in thick dabs of color. In this way he finally achieved the richness of Veronese and Rubens. . . . Like the great Sung artists, he sought to create another order of reality. In the period of refining and mastering technical resources, the metaphysical quality of his final period begins to appear. . . . Cézanne's career parallels that of Beethoven in many ways. Each man was isolated—Beethoven by his deafness, Cézanne by the ridicule of the critics, the public and even the fellow artist." As usual, such analogies are totally ficticious.

Cézanne was an inventor, and most of us are indebted to him in many ways. He was the inspirer, the initiator—but not the perfector. To use his own prophetic words, he was "the primitive of the day," and above all, he had great artistic intelligence—a rarity among wielders of paintbrushes. Many new categories in painting were instituted by Cézanne without his having any notion that he was responsible for such an act. As with all truly creative artistic accomplishments his innovations emanate from the deep strata of the unconscious.

Cézanne disdained the Impressionists; he considered their artistry flimsy and said that they lacked "the solidity of the old masters." But more than that, he despised the slick finish of the academic painters. "I must go on working," he wrote, "but not in order to attain the finished perfection sought after by the imbeciles, which quality, so much commonly admired, makes any work produced in that way inartistic and vulgar." However, Cézanne was not the first to reject the finished perfection; long before him Corot, Degas, and a host of non-academic painters refused to follow the precepts of the academy.

Cézanne's answer to the old order was his neglect to represent pictorial depth with the traditional use of linear and atmospheric perspective. Instead he cut the pictorial space in half—no more nostalgia of the indefinite, distant horizons! In his system all surfaces in depth are parallel to the picture's plane; recessions are created by intersecting and overlapping planes, thus giving modern art a new orthodoxy: recessional flatness which eventually ended in spacelessness. Consequently, atmospheric perspective, the mainstay of classic methodology in landscape painting, was no longer required. This allowed the introduction of an equalized coloristic scheme throughout the painting—that is, colors of the same intensity regardless of their position in space—the first step toward Cubism. Once the colors in the colors in the compound of a painting become "distorted," the forms should

FIGURE 74
Paul Cézanne, STILL LIFE WITH GINGER JAR AND EGGPLANT
Undisputed father of modern art.

follow suit. In using a multiple viewpoint in his paintings—in the same composition some objects are seen from below, some at eye level, and some from above—distortion of the picture's formal elements is an accomplished fact, and with the sacrifice of all extrinsic embellishment and decorative trappings, concentration on the purely structural becomes possible (Figure 74).

Cubism (thus labeled by his followers) was Cézanne's legacy, and without a doubt, it was the most important art instrument at the beginning of this century. Of course, Cézanne was not aware that he was responsible for its invention, but his followers exploited it to the fullest. The principles of Cubism rely on elimination of pictorial depth, or reduction of depth to mere shallow recesses, allowing objects either to become "abstract" or to be eliminated altogether. The "classic" Cubist largely eliminated color, reducing the picture's entire color scheme to monochromes. In addition, a bilateral framework—horizontal and vertical delineations—embraced the "nonobjects," and by projecting their presence onto the negative space (the void around them), created a monolithic, unified picture plane. In actual fact, it takes little ingenuity to produce a Cubistic picture.

In 1920 many students (and I among them) at the Bauhaus in Weimar, Germany, produced creditable Cubistic paintings on a routine basis. Hence, when Clement Greenberg, one of the leading theoreticians of the avant-garde, writes that Picasso's Cubist picture entitled *Ma Jolie* (Figure 75) is "one of the greatest masterpieces ever put on canvas," one is quite skeptical.

110

Cubism in its most attractive decorative form appears in the work of George Braque (Figure 76) where Cézanne's principles were skillfully utilized and ingeniously contrived. In addition, refined color sense aided the painter in creating works of considerable beauty. Could he, then, be given a place in the pantheon of the greatest artists? Not when applying value judgment consistent with the principles developed in this treatise. In the art of Braque, we face a system of semi-abstract decoration that operates from a fixed position. Once the methodology of applying a given decorative pattern has been formulated, successful work can be done almost mechani-

FIGURE 76
Georges Braque, LE JOURNAL
Refined decor in cubistic style.

FIGURE 75
Pablo Picasso, MA JOLIE
Definitely not "one of the greatest masterpieces ever put on canvas."

cally. Thus, because of its diagrammatic nature, the creative effort that goes into making semi-abstract designs carries a low voltage and the hazzard of failure is minimal. But what, one may ask, of the diagrammatic nature of Byzantine decor, for example? Why is it of higher artistic value? The answer is simple: the suprapersonal style of that epoch imbued all works of art with elements of decor that the Modern Age does not possess. Alas, the Machine Age deprived all decorative expositions of their hieratic splendor and timeless validity that changing taste could never destroy. In contrast, the aesthetic appeal of a modern decor is transitory, for it harbors in its matrix a built-in obsolescence.

111

Fin de Siècle: L'Art Nouveau
Chaos in its Inception

AT THE END of the 19th century a fashion emerged which was classified by several names, depending on the locale. In Austria, it was called *Secession;* the Germans followed shortly with *Jugendstil;* and in France it was known as *l'Art Nouveau.* This style was chiefly concerned with interior decoration, illustration, bric-a-brac, and to a lesser extent, with painting and sculpture. Characterized by flaccid design and modish affectation, it was motivated by a snobbish desire for novelty. France and Austria were especially afflicted by the new trend. The misbegotten vogue was short-lived, but in its wake it left an ocean of ugliness; and today, promoted by vested interests, it is once again gaining popularity on the art market. The only painter who is largely responsible for the development of this style, and who rose to considerable stature as an artist was the Austrian Gustav Klimt (Figure 78). To what heights of artistry might the English draftsman Aubrey Beardsley have risen had he not become a victim of the illconceived fashion of his time? (Figure 77). *L'Art Nouveau* was the last futile attempt to create a new style of design before the full effect of industrialization made itself felt, thus ending the era of traditional decor.

FIGURE 77
Aubrey Beardsley, MESSALINA
Characteristic design in l'art nouveau mode.

112

Fauvism

FIGURE 79
Henri Matisse, BLUE NUDE
Sour kitsch

Albright-Knox Gallery, Buffalo, N.Y.

THE TERM DERIVES its meaning from the French *les fauves,* meaning "wild beasts." It was given to a group of Expressionistic painters during the first decades of the 20th century, and it quite accurately describes their working methods (Figures 79, 80). Expressionists in Germany followed a similar direction a few years later, only their senseless savagery was even greater. Nolde and Kirchner, the painters who have attained great prominence today, represent the trend at its worst. Its acceptance by our aestheticians can be explained only by the psychological climate of our time, its lack of artistic standards and the absence of valid criteria of judgment. Unfamiliar with the exigencies of their craft, the German Expressionists produced pictures of extreme ungainliness. Devoid of sensibility, the stridency of their haphazardly applied colors and the arbitrary, gratuitous distortion bears witness to the painters' false heat. The Austrian painter Oskar Kokoschka is one of the few exceptions.

114

FIGURE 8
Ernst Ludwig Kirchner, STREET SCENE
Here realism becomes a highest art form
Museum of Modern Art, New York

Surrealism

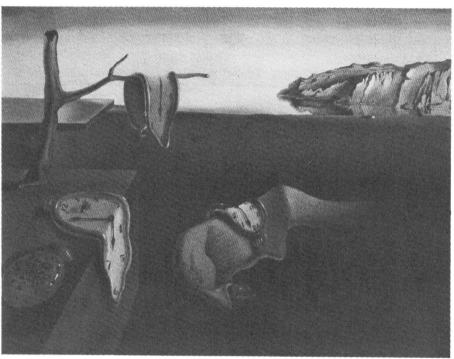

FIGURE 81
SALVADOR DALI, PERSISTENCE OF MEMORY

IN OUR TIME, Surrealism is the only valid instrument of art as story-telling. Painters of that school often employ techniques of the early classic masters, keeping the entire picture on the same plane of interest, with emphasis on sharp visual focus. Pictorial effects, such as variable treatment of contour and accent on texture are generally not the painter's objective. The distinguishing elements of Surrealistic paintings are effacement of the frontiers between the real and the unreal, equivocation, oblique approaches, a calculated pursuit of the illogical, dissociation of ideas, with the objective of creating an ideographic vocabulary of the impossible (Figure 81). Exquisite craftsmanship is a prerequisite for Surrealistic painting that operates with representational objects.

116

Avant-garde

IN TODAY'S WORLD, the obvious and well-proportioned, as we see it in classic art, has become devitalized often to the point of debasement. Hence, the contemporary artist seeking a valid aesthetic equivalent, must condition his forms in some manner. Only on the rarest occasion can he achieve significance when employing realism (Figure 82).

What avenues are open to the 20th century painter, which aesthetic precepts can he accept? Can he follow his visual experience, or must he disengage himself from it? Realistic forms, whether classic and idealized or factual and photographic, have for the most part, lost their purport and authenticity; hence, willy-nilly, the artist must seek other than the ostensible qualities of natural appearance; he must free his work from the infiltration of human content — or he must escape into the never-never land of abstraction.

Avant-garde, by definition, implies "trail-blazing," crossing new boundaries with the aim of discovering new territory. As applied to present-day proponents of the movement, the term is a misnomer. Just as traditional art is rooted in precedent, so today's so-called avant-garde is dependent on prototypes established around the first decade of this century. Following rigid doctrines, modern avant-garde has appropriated systems that are in many ways alien and often antithetic to the nature and meaning of art. What has been presented to us as new, original, and experimental is in fact a rehash of art forms — or we may justly call them no-art forms. Nonobjective amor-

FIGURE 82
Giacomo Manzu, PORTRAIT OF INGE

117

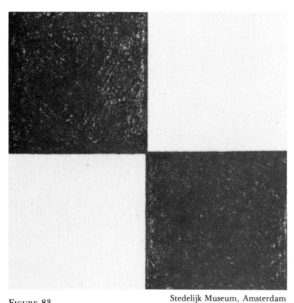

FIGURE 83
Kasimir Malevich, SUPREMATIST PAINTING
The first manifestation of no-art.

champ committed an act of reversal of values—a truly desperate deed! It appears that he was motivated by an intellectual vendetta. Thus by a defiant twist, he turned what he deeply resented into the only desirable goal, and so the absurd, the debased, and the meaningless are shaped into a requisite for masochistic enjoyment. To avenge the loss of his talent—*Nude Descending a Staircase* (Figure 86), the futuristic painting done in his youth, attests to his earlier gifts—Duchamp elevated the trivial, fragmentary and defective, to the realm of art and found in them the only goal worthy of his attainment.

But his influence on our disoriented connoisseurs has been, and still is, formidable. In an interview, the curator of the prestigious Guggenheim Museum in New York, an institution dedicated to "progressive" art, made a

FIGURE 84
Kasimir Malevich, SUPREMATIST PAINTING

phous color patterns and splashes representing nothing in particular were used more than a century ago on silk and cotton fabrics for ladies' dresses and on men's cravats. The difference between those designs and the ones which are doxologized by today's taste-makers lies in one circumstance: whereas the former served utilitarian purposes, the modern patterns and color splashes are framed and hung on walls, and are looked upon as significant art and given metaphysical, mystical or symbolic connotations.

Modern nonobjective painters take their cue from Kandinsky, Malevich, Tatlin and other experimenters working during the first decade of this century, (Figures 83 and 84) and the introduction of no-art objects must be credited to Marcel Duchamp. After abdicating his status as a painter, he chose junk and debris and all manner of machine-made things, which he called *objets trouves*, (literally, found objects—Figure 85), as the vocabulary of his "artistic communication" Du-

118

statement to the effect that, "From now on there is not going to be art as we have known it because the *professionals* [my italics] are not using conventional materials such as paints, brushes, and canvas. These are now the requisites of amateur painters. . . . Well," he continued, "the museums displaying art created before the middle of the century will look like the art of the Louvre: this art will be seen in its historical perspective."

As paints and brushes became *declassé*, the avant-garde artists adopted another method of composing "works of art" called *collage*. In 1920, when I attended the first academy of nonobjective art—the Bauhaus in Weimar, Germany—our teacher, the unforgettable Johannes Itten, would send us to the city dump to collect *objets trouves*. Wherupon we would arrange the materials on boards so as

Figure 86
Marcel Duchamp, Nude Descending a Staircase

Figure 85
Marcel Duchamp, Bicycle Wheel
A euphemism for "junk."

to elicit their inherent properties. The formal rationale of this attempt was to stress the diversity of their optic and tactile qualities by emphasizing their overt characteristics. Thus, the soft bits of textile were coupled with pliable twigs and twine. The volumetric was contrasted with the planimetric, and the polymorphous (fragment of a brick) with the monolithic (piece of pipe.) A mellow color was pitched against a strident one—point and counterpoint—harmony and dissonance, the tectonic and the amorphous—*coincidencia oppositorum*. Compared with collage as practiced at the Bauhaus, the frontiers of present-day practitioners have not widened. Avantgarde sculpture employs pieces of metal or wood joined together or, as the case may be, loosely assembled in an arbitrary manner, and there is no conceivable reason why the disposition of such an object's elements could not be altered at will by anyone without creating any difference in its over-all "artistry."

119

Modern Architecture
The Demise of Ornamentation

WHEN PLANNED ON a large scale, modern architecture can stun the eye with aloof grandeur, but it does not elicit sentiment or sympathy because it always lacks charm—a word now under the strictest aesthetic embargo. Modern architecture is functional; it holds one in the low registers of sobriety, for functionalism runs counter to man's natural desire for the ornate. Human abode can be regarded as an extension of the human body, and man's aesthetic concern came into being when he first adorned his body with ornaments.

Practicability, usefulness and purposefulness rule modern architecture, and these do not admit of sentimental attachment and the impulsive vagaries of the human heart. Precision is the moral imperative of machine-made objects, and Time is their greatest enemy. Time can glorify man's handiwork, but it inexorably renders the machine absurd; it degrades and debases all its products. The machine personifies man's desire for efficiency, and efficiency is the machine's ultimate goal and destiny.

Modern architecture and ornament are at cross purposes, for the mechanistic holds in its glacial grip the chief concern of technology: cheap construction and efficient maintenance. It is cheaper and simpler to put up studs for a six-room house than to carve a single Corinthian capital; it is easier to remove grime of the facade of a modern house than to clean it from a Baroque portal.

When does modern architecture achieve its aim and when does it fail in its objective? In the big cities, modern architecture was the first authentic style to appear in more than a century. But when applied elsewhere, the same style can be veritable abomination. In the modernistic church buildings, for example, modern art forms are truly absurd—they are anti-mystical, anti-ecstatic and anti-romantic. They are inimical to mythology, theology, metaphysics; they induce neither reverence nor piety nor contemplation.

Modern architecture is, more often than not, at odds with the essence of a landscape; it fights nature's capricious configurations and her unaccountable fortuities. It is in disharmony with practically every form found in nature—unless it is based on some fitting non-technological pattern, or unless it conforms in some ingenious manner to the existing topographic conformations. Moreover, even if we consider a modern version of a traditional pattern, the modern structure will never be identical with the original, because when it is fashioned with modern mechanical tools the characteristics of the structural elements in regard to their contours will be different. In addition, the textural appearance of the surfaces, uninfluenced by time and its abrasive touch, will not have the "antique" traits of dwellings that have had a long communion with nature and her elements. I am thinking specifically of the modern "Gothic" churches; no matter how faithful the reproduction, they will always be but spurious imitations.

We say that modern architecture has categorically abjured ornamentation, but this is not always true. Once officially legislated out of existence, ornamentation now appears in architectonically conceived shapes which serve no structural purpose. The Opera House in Sydney, Australia, is a prime example of such misapplied extravagance.

Ambiguity in Art

I SHARE A basic mistrust of philosophy with Bernard Berenson, who called that particular mental effort an "exercise in diseased semantics," and with Lord Russell, who refers to it as an "ingenious way of fallacious thinking." Nevertheless, I shall quote without acerbity from Ortega y Gasset, who justly maintains that, "A modern work of art must be invested with multiplicity of meaning,"—that is, with ambiguity. Along these same lines, the eminent historian H.J. Muller writes: "The deepest things, or the loftiest imaginings, are usually not the clearest." Notwithstanding the reasonableness of this statement, if anything appears to be "deep" or not too clear, one may—in most circumstances—suspect that mud has collected at the bottom.

Ambiguity has always been with us in one form or another. The fragmentary and uncertain nature of a sketch, for example, accounts for its intrinsic charm—specifically, the freedom given the beholder to examine and interpret it after his own fashion. When the artist leaves a third leg on the sketch of a figure, instead of erasing the one with which he was dissatisfied, this creates ambiguity, for it puts us in a quandry as to which one we should discard as the expendable leg. There is a statement in a 16th century guidebook to Florence which asserts that Michelangelo's unfinished statues of the *Slaves* are even more admirable than the finished ones. Here again, the suggestive sketchiness stimulates the beholder's interest and imagination. On this subject, Diderot wrote: "A sketch is generally more spirited than a finished painting. It is the artist's work when he is full of inspiration, when reflection has toned down nothing; it is then that the artist's soul speaks to us freely ...A few strokes express the rapid fancy, and the more vaguely the art embodies itself, the more room there is for play of imagination."

The current use of the word *ambiguity* offers an interesting study in semantics; the word stands for "obscurity," and is often a derogatory term. It is one of the tactics of the avant-garde to use words that were once considered abusive, and turn them around for shock effect, thus ambiguity has become a weapon for concealing a lack of knowledge, skill and purpose. It might just as well be applied to fragmented pieces of metal, torn rags or paper—all sorts of junk and debris assembled at random and presented to us as examples of authentic avant-garde creativity. Ambiguity and unintelligibility have become interchangeable, and the obscure and meaningless are the objects of the critics' and the public's admiration. Finally, ambiguity applies equally to a work with multiple meanings or no meaning at all. As the vortex of a system or style of painting, the methodology of the ambiguous is questionable, for like mysticism, it is a quality whose merits are lost without the peculiar personality to which it is welded. In the end it is the degree of ambiguity in a painting and its nature that makes it work.

FIGURE 87
Piet Mondrian, Composition 2

FIGURE 88
Henri Matisse, DRAWING

Museum of Modern Art, New York

The Failure of Art Scholarship

ONE OF THE strange phenomena of human nature is the compulsion that forces some of us to divert our energies to artistic pursuits. These enigmatic drives existed long before written language—and possibly before verbal communication as we know it now. Likewise, there have been interpretations of the nature of artistic creativity and artistic creations throughout the ages, and the torrent of cliches from "informed" quarters has continued unabated for centuries. Unfortunately, an individual whose main occupation is that of writer is as a rule, not a reliable art critic. Since his primary concern is with words, his observations may be less a result of objective scrutiny of a particular work of art than a product of attention given to the manipulation of his own verbiage. In such cases, the attempt to endow said verbiage with meaning is, more often than not, an act *a posteriori*.

I was prompted to take up my cudgel once again when I ran across an old canard, solemnly propounded in the sophisticated magazine, *Horizon:* "Had Seurat never painted a picture, he would be famous for his luminous drawings—indeed for his Conté-crayon drawings alone." This is a standard opinion of "experts" who are apparently una-

ware that this "luminosity" is produced by the mechanically impressed texture of the paper, brand name "Ingres," which could never allow the sensibility of the artist's hand to assert itself. Anyone attending European art classes early in the century where the use of such charcoal paper was customary, could have seen drawings from the hands of any student that displayed identical "luminosity."

Later a severely erudite disquisition taken from a well-aged catalogue of profound irrelevancies appeared in the publication mentioned above. This one concerned the "hidden meanings" of one of Giorgione's paintings, sometimes called *The Tempest* (Figure 89), generally considered by art authorities to be his best. Without embarking on scholarly circumnavigation, let me say that this painting lacks distinction and is inferior as a composition. A painting of indifferent color or paint quality can qualify as a masterpiece, but if it fails as a composition, it ceases to function as a great work of art. Why is *The Tempest* faulty? Its protagonists are not arranged in proper perspective, the observance of which was axiomatic under the Renaissance system. Thus, the standing figure is much too small in relation to the seated figure, besides it is

Academia, Venice

Figure 89
Giorgione, The Tempest
An example of a poorly composed painting by a great artist.

placed too near the edge of the picture. The two broken columns beside the standing figure are architectonically incongruous, and formally they create disharmony between the main elements of the composition. Predictably, the author of the article refers to the columns as possible "phallic symbols," a conjecture typical of scholars searching for nonexisting, or aesthetically irrelevant meanings. It is heart-warming to read the author's ironic reference to "...Victorian sentimentalization and *enbourgeoisement* from which the picture emerged as the *Family of Giorgione.* This numbingly domestic title can still be found in art encyclopedias (vintage 1880) in otherwise respectable British and American libraries."

Here the author implies, not without satisfaction, that the lowly sentiment is not only dated, but ludicrous as well—as if today's verdicts will never lose their vernal freshness and appear dated a few years hence. The scholars who have written on the subject of *The Tempest* apparently do not realize that they have "been had" by the indisputably romantic mood of the painting, and that the search for any "hidden meaning" is pointless.

The history of art criticism is repleat with glaring misstatements. For example, the eminent writer Gerard Del Laraisse, who consented to have his portrait painted by Rembrandt, recorded his opinion of the master in these terms: "Rembrandt is a painter capable of nothing but vulgar and prosaic subjects who merely achieved an effect of rottenness." One can only surmise that Rembrandt's likeness was a bit too accurate for this critic's taste. His fellow connoisseur, the poet Klaas van Leyden, chimed in: "Rembrandt cannot disguise the paucity of his imagination by decking himself in finery for his self-portraits. In

125

his attempt to do grand paintings after the style of the great masters, he succeeded in nothing more than showing his vulgar taste and utter lack of color sense." The year was 1648; a hundred and fifty years did little to improve matters in the field of art criticism.

Consider, for example, Johann Wolfgang von Goethe, one of the brightest intellects of all time, who was a contemporary of Goya and his great compatriots, the painters Caspar David Friedrich and Phillip Otto Runge. Whom did Goethe admire? Peter von Cornelius and Antonio Canova, the pseudoclassic academicians. And when the Boissirie brothers invited Goethe to study the glorious collection of Gothic art which they had assembled after the Napoleonic wars, steeped as he was in Neoclassic doctrines, Goethe confessed his inability to comprehend the aesthetic of Gothic configurations, an inability he shared with Vasari and other eminent theoreticians. To his credit, however, Goethe expressed his own inability, while Vasari referred to Gothic art with utter contempt. It is also interesting to note Goethe held Carl Maria von Weber to be a greater artist than Beethoven.

The writer's fundamental incapacity to relate to visual art expresses itself malignantly in this statement by Lord Byron: "I know nothing of painting and detest it, unless it reminds me of something I have seen or think it possible to see; for which reason I spit upon and abhor all the saints and subjects of one-half the compositions I see in churches and palaces. Of all the arts it is the most artificial and unnatural and that by which the mind of mankind is most imposed upon. I never saw a picture or statue which came within a league of my conception or expectation." A generation earlier, Horace Walpole considered Hob-

bema, Ruisdael and the rest of the splendid Dutch landscape painters to be ". . . drudging mimics of nature's most uncommon coarseness."

The eminent scholar Max Friedlander, whose knowledge of the art of the Netherlands is unequalled, wrote about Cézanne's ". . . wizardly and ravishing melody of color, his hypersensitive eye for the nuance of color." He also avers that, "The object was for Cézanne nothing but a chromatic surface," which of course is unsupportable, because accent on color and Cézanne's pictorial system are mutually exclusive. However, Friedlander himself provides the most cogent explanation for these maunderings when he acknowledges that, "Most judgments on art are formulated at the writing desk in front of reproductions."

Predictably, other famed specialists in aesthetics fared no better. For example, John Ruskin's name still shines bright in the firmament of art connoisseurship; and like the aestheticians of today, the judgment of the great Victorian cognoscente was often less than accurate. Said he of Leonardo: "Because he made his models of machines, dug canals, built fortifications, and dissipated half of his art power in capricious ingenuities, we have many anecdotes of him, but no picture of importance on canvas." What keen powers of observation! Leonardo never painted on canvas. Then the eagle-eyed expert adds: "Guido Reni [a Baroque hack] is a man ten times as great as Leonardo." Ruskin did not confine his attentions to painting, of course, and had equally incisive views on architecture: "It is generally to be observed that the proportions of buildings have nothing to do with the style or general merit of their architecture. An architect trained in the worst schools and

wholly devoid of all meaning and purpose in his work, may yet have such a natural gift of massing and grouping as will render his structure effective when seen from a distance ornamentation is the principal part of architecture." I say to you that just the opposite is true, for good architecture is almost entirely a matter of proportion and massing, and that the general effect of the whole counts for everything. Alas, Ruskin's connoisseurship as regards music was not much better. In a letter to John Brown, dated February 6, 1881 he wrote: Beethoven always sounds to me like the upsetting of a bag of nails, with here and there a dropped hammer.

Ruskin's admiration for Guido Reni does not alter our opinion of this mediocre painter, and Lord Kenneth Clark's contention that Mondrian is the direct inheritor of Vermeer van Delft's system of aesthetics, or that Monet's paintings, the *Lily Pond* series in particular, presage the advent of Abstract Expressionism, fills me with profound disbelief. On this theme, Sir Herbert Read wrote: "It must be confessed that a great deal of contemporary action painting, as it is at its best in a Pollock or a Kline, has plastic and spatial potentialities which, however spontaneous in their execution, are the end product of a process of intellectual sophistication. Ape-painting at its best may be said to represent a perceptual control of calligraphic energy; action painting, by contrast, is a calligraphic exploration of spatial volumes and implies a psychological motif of intention which is not present in the random scribbling of the ape."

And that prominent theoretician of action painting, Harold Rosenberg, heralds thus on Pollock (as reported by Tom Wolfe): "A Promethean artist gorged with emotion and overloaded with paint hurling himself and his brushes at the canvas as if in hand-to-hand combat with fate. There, there! In those furious swipes of the brush on canvas, in those splatters of unchained id, one could be the artist's emotions itself — still alive! — in the finished product." It is with deep embarrassment that I read such pretentious and meaningless dribble.

In Malraux's writings on practically every page we find a veritable witches' Sabbath in which Kushmisha vases, Haida objects, Coptic fabrics, the Hopsis, Sumerians and, invariably, Cézanne, hold an unholy communion. Ravishing rhetoric, one must admit, and expanded to a hundred-thousand words we have the chorus of *Voices of Silence*, André Malraux's magnum opus. Malraux perhaps the most celebrated wizard of modern aesthetics; he had a conventional knowledge of metaphysics, philosophy, literature and art history. His convictions complied with the fashions of his time, and he operated with a formidable terminology calculated to mesmerize the reader into assent. In the matter of analogies, Malraux showed unequaled grandeur, and in an effort to establish an aesthetic pantheism, he pontificated: "On this plane, the *Koré of Euthydikos* is a sister to the most poignant Christ crucified, *The Thinker*, a pre-Colombian figure, even the *Beggar Woman*, the *Three Crosses* and the best Buddhist paintings share in the glory of the Panathenaic frieze, in the cosmic frenzies of Ruben's *Kermesse*, the brooding horror of *The Shootings of May Third* and perhaps in that purity of heart which Cézanne and Van Gogh brought to paintings."

The hard-bitten art historian will ask, however, for more exacting scholarship than

Malraux's poetic metaphors offer, no matter how enticing their suggestive power. The professional philosopher, too, will find in Malraux's system holes large enough to accommodate some of his own hypothetical doctrines, more exact and less fulminant, perhaps, though equally futile. In Malraux's generalized scheme of things, the stance of which is too aloof to be approached with a pedestrian sense of proportion, the *Bison of Altamira* chases Leviathan, who, in turn, circles Picasso's *Demoiselles d'Avignon* (Figure 33), and the eons hail each other from here to Ultima Thule. "Under the beaten gold of the Mycenean masks, where men saw only the dust of dead beauty, there throbbed a secret power whose rumor, echoing down the ages, at last we can hear again. And issuing from the darkness of ancient empires, the voices of statues that sing at sunrise murmur to Klee's gossamer brush strokes and the blue of Braque's grapes."

Thus, in contemporary art criticism conditions of supposed excellence of a work of art have no rational basis, for this criticism is always obscure, contradictory and bereft of all meaning. Take for example this interview between two art critics and Mr. Alfred Barr, a former director of the Museum of Modern Art in New York:

> **Interviewer:** *What makes a picture less than major, not as good as others?*
> **Museum Director:** *I'm afraid nobody has ever figured out a way to measure, to qualify quality. You can't attach a wire to a picture and have it ring up "masterpiece." We are all making assumptions. Quality in art is not subject to proof [sic!]. We make our judgment as individuals. We also tend to form collective views. There are times when my view differs from the collective view, and times when it doesn't. I am sure all three of us would feel that Barney Newman's Vir Heroicus Sublimus is really one of his great pictures."*

This picture, measuring 8 by 20 feet, represents a solidly colored surface divided by four thin vertical lines. What instrument of judgment could one summon to qualify the picture as "great"? Could a house painter's apprentice produce an equally "great" picture? There is little doubt that he could. We may also note that when defending his acquisitions, Mr. Barr stated that his selections are justified ". . . even at the risk of having guessed wrong nine times out of ten," Thus, the "experts," in making their aesthetic appraisals, are engaged in what appears to be a hazardous guessing game.

In support of this contention, Sir Herbert Read, in his book *Philosophy of Art,* writes with reference to Abstract Expressionism: "The greater part of American painting is merely a tidy doodling devoid of sensuous harmony or elegance. Such art is popular, I suggest, because it is a perfect mask—a form of communication that, like the carefully worded 'press release' issued by statesmen, tells the public precisely nothing. It is the art form of a society directed by its neuroses toward anonymity and uniformity."

Sir Herbert, who has aided and abetted avant-garde since its inception, seems to have suffered a change of heart. No wonder, for this modernism, having been accepted by the common man, has at last lost its one-time esoteric flavor. A similar motivation appears to have guided the reasoning of the leading exponent of the American School of non-communication, T.B. Hess, who wrote of the

sculptor Henry Moore: "The inflation of his reputation is mainly the achievement of British intellectuals who, at the end of the last war, needed *chefs d'ecole* who would be: native, yet continental in style; metaphysical for metaphors, yet natural (i.e., connected with a country garden of the soul); verbally socialist in human sympathies yet aristocratically aloof in stance. In his exhibition of sculptures, bits and tags from prehistoric China, Etruria, Alexandria, the Gold Coast, the Cyclades, widen the reference of his figures only for those who look at them with an open history book in their mind—a book whose pages block the glance from eye to object."

Thus Mr. Hess, one of the shapers of official taste, deprecates the official art and repudiates the very premises upon which the aesthetic allegiances of modernism are instituted; and in doing so, he rejoices in the secret knowledge of being a holder of a super-esoteric cognizance entirely inaccessible to the common man. It is therefore not surprising to read in *New York Magazine* this rhapsody of farragoes of intellectual nonsense: "Mondrian couldn't abide curves. . . . you feel that you have somehow slipped into the hushed atmosphere of Vermeer." And, operating on the compulsion of his syndrome, he continues: "The warmth of what William Blake called 'lineaments of gratified desire' beams from works of such artists as Piet Mondrian."

This leads one to the inevitable conviction that the critic who follows the direction of the so-called avant-garde, in eulogizing no-art, elevates himself to a higher plane, and in vitiating traditional values he destroys all the accepted standards—standards that would allow him to correctly evaluate the artist and, in the final analysis—himself.

Clement Greenberg, who was at one time the most influential proponent of avant-garde art, had this to say of Mondrian: "His pictures with their white grounds, straight black lines and opposed rectangles of pure color are no longer windows in the wall, but islands radiating clarity, harmony and grandeur—passion mastered and cooled, a difficult struggle resolved, unity imposed upon diversity." Obviously, the critic, while under the influence of a rhapsodic afflatus, did not realize that even without the use of masking tape any semi-skilled practitioner could easily achieve similar grandeur without unduly straining his creative faculties. And professor Meyer Schapiro, a distinguished scholar writes: "In comparing the arts of our time with those of hundreds of years ago we observe that the arts have become more deeply personal, more intimate, more concerned with experiences of subtler kind." It is with deep dismay that I witness such debasement of mind, such an obsequious attitude in an art professor whose career depends on making obeisance to what the intellectual elite considers "progressive." Indeed, Bach, Mozart, Haydn, Leonardo, Brueghel, Goya—to name a random few—did not succeed as do our modern greats in becoming "deeply personal, intimate, and subtle." To what heights would they have soared had they been born in the 20th century!

Apparently the modern art critic is incapable of developing any reasonable relation to the art of painting, let alone the ability to judge it. It would seem those with a propensity for verbalization are not concerned with value judgment in matters of art, regardless of their proficiency in the field of literature.

To illustrate further, Lord Kenneth Clark, former director of the National Gallery

FIGURE 90
Henri Matisse, THE DANCE
Schematized, perfunctory design, trivial color, inept handling of
the paint material.

in London, writes of Henri Matisse's *The Dance* (Figure 90). "It was painted with an inspired frenzy and communicates more vividly than any work since the Renaissance the sense of Dionysiac rapture." The eminent scholar was either unconcerned with, or unaware of, the perfunctorily schematized, that is stylized design of the figures, the inept handling of the paint material, and the trivial coloring; instead he was preoccupied with the illustrative content of the picture—an anathema to modern aesthetics. Now surely, during a period of half a millennium, there must have been some other examples of "Dionysiac rapture" equalling or even surpassing the performance of Henri Matisse's *Dance*.

The critic's unanimous opinion of Matisse's drawings is expressed thus: "It's the drawings that are of greatest interest...the most passionate logical form drawn with no more than a cursory line or two—but what a

bold, authoratative line it is...As an unrivaled champion of line he is unequalled in the 20th century." And: "Matisse's ability to draw came only after enormous struggle.... The range of his drawings is, staggering; he tried and succeeded at everything with pen as well as with pencil and charcoal."

The drawings reproduced in Figures 91 a and b are no worse than any other from his hand, and it should be apparent to anyone not mezmerised by his name and his overblown reputation that they are inept and possess neither "logic," "passion," nor "authority." In other words, his graphic line is inert and lacks sensibility — his hand is not guided by nervous impulses, whatever.

In regard to his paintings, all aestheticians, without exception, went overboard in rapturous encomiums about his pictorial prowess. Thus one reads:

"One is especially struck by the boldness

130

Museum of Modern Art, New York

FIGURE 91A
Henri Matisse, DRAWING
"Knowledge arrived at after enormous struggle."

teractions between curved and straight, open and closed, centripetal and centrifugal, in the relationship between a reclining body and the acrobatic positioning of its arms and legs, and even in odd distinctions between the eyes in a face, where one is mobile, the other immobile (a device that became systematic with Cézanne). When the polarities are established so that each preserves its identity while being equilibrated and inter-related, the works have almost awesome beauty and force."

Of course, none of the dreamed up qualities have a basis in fact. When scrutinizing his paintings soberly one must become aware that just the opposite is true: his color is trivial, the treatment of light and shade nonexistent, the compositions are more often than not at fault, and the decor is invariably attrocious to say the least. And, what we have come to look upon as "paint quality", none of this is evident in any of his paintings.

FIGURE 91B
Henri Matisse, DRAWING
Museum of Modern Art, New York

of the painter's color, the virtuosity of his treatment of light. Like Cézanne, Matisse believed that light should be expressed by means of plastic equivalents. Artists had long known that it is impossible to paint sunlight or the deepest shadows at their real intensities, that such means simply do not exist."

"His command of color, his genius as a composer of broad, contrasting planes, his ability to order a sequence of shapes and employ spaces is unequalled.

"His understanding of decor combined with representation of the female figure, modern in conception, yet containing classic elements, can rarely be found in contemporary paintings."

"Because his equilibrium is built on tension rather than on a detail of it, Matisse's art, at its best, has to do with freedom. Within the immobile context of setting and pose (with, of course, a few notable exceptions), there is tremendous movement. Space is expanded and contracted, figures and objects are opened up, run together. The basic opposition of rest and movement is felt in in-

131

Of his own work, Matisse writes: "What I am after above all is expression...the whole arrangement of my picture is expressive... composition is the art of arrangement in a decorative manner...for the expression of what the painter wants...What I dream of is an art of balance, of purity and serenity, devoid of any troubling subject matter, like a good armchair in which to rest from fatigue ...What I dream of is the attainment of a child's naiveté." Matisse was not a keen thinker—there can be little doubt that a child's naiveté cannot be attained by an act of will.

When referring to the "greats" of our time the name Picasso, a household word even among the unlettered, merits special attention. His rise to a position matching that of Michelangelo could never have taken place without an unprecedented promotion aided and abetted by the lack of standards in modern aesthetics.

Undeniably, in his youth Picasso was endowed with considerable talent, but as with so many artists who have matured early, it evaporated before he reached middle age. A similar statement was made by Bernard Berenson concerning Raphael: "Were he [Raphael] to have lived beyond the age of thirty-seven, he would have ended up a Giulio Romano." (Romano was Raphael's assistant—a dry-as-dust academician.)

With the discarding of standards, evaluation has become a matter of promotion rather than rational diagnosis. When the cognoscenti refer to one category as representing a high point in art and ignore another, this is not a matter of value judgment. It is done for strictly strategic purposes, for without a hierarchy of high priests no cult can be established. Every religion—and the worship of non-art is in the nature of a religious cult—is built around a sanctified deity and requires for its solemnization a coterie of apostles.

With the ensuing collapse of artistic standards the only aesthetic principle and new

FIGURE 92
Pablo Picasso, NUDE IN A CHAIR
Unwarranted abuse of anatomy.

Picasso Estate

breed of cognoscenti now accept is nonconformity to all tenets valued in the past; they consider anything remotely connected with tradition a hopeless anachronism. Under such conditions it is little wonder that the aesthetic misadventures of Picasso's middle and late years have become objects of universal veneration. Any trite work that carries his signature is automatically elevated to the position of "masterpiece" (Figure 93).

True, liberation from the rigors of convention has been the artist's prerogative; he practices it with various degrees of success, conditioning the anthropometry for the sake of greater expressiveness. But in Picasso's late work there is no warrant for the savage abuse of anatomy. A distortion can be justified only if the assumed aberration serves to heighten, clarify, metaphorize, or dramatize the stresses of anatomic structure—and only if it is direct-

ed toward credible organic function. If the deviation from facts as seen in nature transcends the natural appearance while retaining the organic nexus, a distortion will "function." It must be emphasized that it is just as difficult to distort convincingly as it is to follow the classic anthropometry without draining it of authenticity and vitality. *Vide* the statuary of the Neoclassic sculptor Canova and other imitators of the classic mode. In their attempt to resuscitate the Periclean Olympus they populated it with sugar-coated Apollos and Venuses, finely sandpapered and nicely touched up with a powder puff.

To repeat, the apologists of avant-garde art, no matter how great their literary skill, are not conditioned by visual experience. We can even go so far as to say that, in their negation of all the aesthetic precepts from the past, their mental attitude toward art is one of hostility. How can one justify the decision of a jury composed of leading European and American art critics and museum directors who bestowed first prize at the prestigious Venice International Bienniale on a paint-splattered blanket, topped by two much-used pillowcases, the whole thing nailed to a board and called *The Bed*? Similar examples could be extended ad infinitum. And, since no criteria of aesthetic could have served the jury as instruments of judgment, we can only assume that in making their decision the distinguished connoisseurs were motivated by one thing only: a profound contempt for art.

Katherine Kuh wrote in *Saturday Review* of the followers of Barnett Newman: "But the fact remains that art today is pared down to rigorously elementary forms and to all but anonymous impersonality.... Today the younger artists see in Newman's vast simplified color areas a degree of reality they can respect. These paintings, they feel, are not involved with any form of symbolism or personal identification; they are based on color and they are color—nothing more, nothing less. With certain Newman followers, this idea is carried so far as to limit an entire canvas to only blue, or red or yellow; for them, the amount of color and the color itself are all that counts."

This critic, it appears, has never asked herself whether the "artists" she so consistently glorifies have any talent at all. What entitles them to call themselves artists? Do designations such as "anonymous impersonality," "hard edge," "primary," "minimal," "op," "pop," and so on legitimize an object thus classified as a work of art? Do the proponent of no-art ever consider the condition of "the difficulty of doing it," and the fact that to perform in the manner of the avant-garde requires no talent? Isn't it obvious that any half-skilled amateur could do just as well as some of our celebrated matadors of the avant-garde, hasn't it been proven time and time again that the critics are unable to distinguish between the "phony" and the "genuine?"

Alas, the brilliant connoisseurs quoted on the preceding pages did not consider Bernard Berenson's dictum: "All words and verbations are checks against deposits of facts that may never be exceeded."

FIGURE 93
Robert Morris, LABYRINTH

Art and the Psychologists

IN ADDITION TO the theoreticians, and the speculative philosophers, the 20th century has seen yet another group join the fray—those surveyors of unconscious motivation, the charters of compulsions and neuroses—the psychologists have put into motion their involved apparatus of "analytical" thinking in quest of answers to the problems of *art*. In my opinion, their modus operandi, acute as it is, is at an impasse when confronted with any kind of artistic expression. It is, therefore, not surprising that this pseudo-science has become bogged down in the imponderables of aesthetics, which do not depend upon clinical states of neurasthenia.

Now, we may say that a basic substance of life is insecurity. In the words of St. Gregory: "In the struggle against death all the arts and sciences have their roots." The artist's search for beauty and perfection is a quest for immortality, and the modern psychologist's proclamation that, "Any resemblance between the beauty of a work of art and the artist's pure devotion to it is merely accidental," lacks authority.

Would the psychologist have us believe that an artist does *not* paint in order to perpetuate his name, to acquire prestige—not even to pay his bills? And this is not to mention man's natural curiosity to explore the world of visual ideas, his desire for freedom from the coercion of "logical" thinking, his inventive spirit, pride in the skill of his hands, discovery of new precincts of nature and facets of his own imagination, the creation of things of beauty—to arrest the inexorable flight of time, to hold fast to a fleeting moment! These are the tributaries of creativity, and they are expressed in a handful of words by the poet Hölderlin: *"Des Meeres Woge schäumte nicht wenn nicht der schwere Fels des Schicksals ihr entgegen stünde."* ("The wave of the sea would not surge if the massive rock of destiny did not stand in its way.")

The psychoanalysts, the high priests of the unconscious, even the genius of Freud, have failed to elucidate the workings of artistic creativity. Of all Freud's writings, those on art are, to me, the least convincing; and his "sublimation theory" is not only nebulous but simply false. Freud's followers and their disciples, with their compasses all askew, seem to be caught in a morass of unsubstantiated theories. Otto Rank claims that, "The aesthetic states of mind occur in particular kinds of personalities in order to release acute psychological tensions due to activation of destructive rage which is not being sufficiently repressed." It is further stated that, ". . . the artist is liable to fall ill occasionally with neurotic depression—not recognized as mental illness." In other words, according to the psychoanalyst, the artist is maladjusted in human relationships, he suffers from inner discord, narcissism, aloofness, and so on. Hence, art is merely a high form of occupational therapy, and the Muse under whose stimulus creativity is activated is really regulated by the Oedipal figure. Brought down to the simplest terms, it is suggested that the artist paints so that he will not have to spend time on an uncomfortable couch in a stuffy psychoanalyst's office.

This view is not entirely accurate, I assure you, for the fabric of an artist's mind is not thus constituted, and different agencies are at work within him to feed his creativity. Since a relatively small number of people are "afflicted" with artistic drives, we may assume that this drive is not just a part of the standard equipment built into the human psyche, but rather an extrinsic, extraordinary force which we may classify as a desire for *aesthetic gratification*. The need for this gratification is a sovereign, autonomously functioning entity which, like the mythical sixth sense, is present in some and nonexisting in others.

In this respect it is strange that no one has investigated rationally, soberly, and without professional bias the apparent contradiction between the artist's emotional condition and the character of his artistic release. Here may lie the proof of my contention that the artist's Muse is independent of the standard libidinal forces within him. Amidst the deepest despair, Mozart, Beethoven, Schubert, Frans Hals, Michelangelo—to mention but a few—created works exuding gaity and confidence; and inversely, an artist in a happy frame of mind may produce a pessimistic artistic expression.

This brings me to a curious observation: does the work of the rogue, the blasphemist and nun-seducer Fra Filippo Lippi convey less pious feeling than that of the saintly Fra Angelico? And what of Goya's compassionate depiction of cruelty in *Desastres de la Guerra?* Was he emotionally involved in the tragedies? Possibly, but not necessarily. When I asked George Grosz, the bitter social commentator, whether he really hated the pre-World War I German military and the bourgeois, the subjects of his devastating graphic invective, he answered: "I don't know, really, I am just fascinated by their meanness and grotesque ugliness." It is also interesting that Van Gogh produced his most serene paintings at the depth of his emotional distress when a patient in the mental asylum of Saint-Remy.

How much, then, does the artist's personal life—his emotions and extra aesthetic predilections—mirror itself in his work? Does the condition of involvement activate his creativity? To answer the question we may listen to the inspired *First Flute Concerto* by Mozart (K. 285, 285A). It was commissioned by the Dutch music patron de Jean and written by the composer because he badly needed funds, and, as he tells us, under great reluctance and displeasure because of his aversion for the flute! Or, take for example, the tragic life of Frans Hals, oppressed as he was by proverty and personal sorrow. Is there even the slightest trace of his vicissitude reflected in his work? In short, when "creating" the artist does not necessarily reach into the well of his emotions; he is occupied perhaps unknowingly with formal problems—issues of aesthetics that are totally alien to the non-artist.

Consider in this context the curious statement made by Jerome Melquist in the highly esteemed *New York Times.* He wrote, "Angrily completing his mural *Guernica,* Picasso, it seems, dropped many leagues through the floor of European civilization to the rocky island of Patmos where John wrote the book of Revelations. For Picasso, likewise, had propounded the alpha and omega of things and crossed through the fire to the ultimate ledge of conviction." Now we may inquire, was Picasso angry during the process of painting the *Guernica?* Or when he cleaned his brushes? At night too? Did he lament as much the rape of Budapest as he did the bombing of the village of Guernica? Or was the tragedy of the former not of his artistic concern?

Examples of blatent critical absurdities are endless, but let us close on the dismal note that programming the public's mind by the preceptors of "progressive" art is fairly complete. The distinguished political commentator, Max Lerner, wrote in the *New York Post* on the occasion of Picasso's death: "It was hard to aim at greatness while he [Picasso] was around, like trying to breathe in a room where a giant was using up all the air." This sounds to me like a prepared image in the commentator's mind for which he sought a subject and found instead a *non sequitur.* And in conclusion, I offer you one of the finest illustrations of the fallacy of modern art criticism in this passage from the memoirs of Cézanne's dealer, Vollard:

"At one of my Cézanne exhibitions there was an item depicting female nudes in the open air, and a figure that might have been taken for a shepherd, judging from the costume. This canvas was in a frame from which I had forgotten to remove the former title, *Diana and Actaeon*. The picture's subject was subsequently described in a press notice as *Diana Bathing,* and an art critic went out of his way to praise the dignified bearing of the goddess, and the impression of chastity given by the virgins surrounding her.

"Not long afterwards I was asked for the *Temptation of St. Anthony* by Cézanne, to show at an exhibition. I promised to send the picture, but then found it had already been sold. So I dispatched instead the so-called *Diana and Actaeon*. But the gallery was expecting the *Temptation of St. Anthony,* and entered the title in its catalogue. One of the newspapers then proceeded to discuss the painting as it it were really the The *Temptation.* Whereas previously the noble attitude of Diana had been praised, the critic now discovered a 'slyly beguiling smile' in one of the daughters of Satan! Next time I saw Cézanne I told him about the various metamorphoses his picture had undergone. He answered: "I wasn't thinking of any particular subject at all. I was just trying to render certain kinds of movements."

Now, I wonder, if Picasso's *Guernica* had been entitled *A Scene from the Ballet Russe de Monte Carlo*. . .what would have been the critics' reaction?

Index

Alla prima painting—painting wet-in-wet from start to finish

Arcade—Arched gallery

Carolingian—pertaining to the period of the 8th to the 10th century in France.

Configuration of paint—the tectonic appearance of the paint surface.

Entablature—part of the classic roof resting on columns

Fenestration—overall design of window arrangement.

Flying buttress—support of a wall in the shape of an arch segment.

Glaze—a transparent film of a darker color applied to a lighter underpainting.

Genre painting—using themes of every day life.

Impasto—a thick layer of paint.

Kitsch (German)—sentimental, trite subject matter.

Ogive—pointed (Gothic) arch.

Pastose—paint thickly applied.

Pediment—low triangular gable crowned with projecting cornice.

Pentimento—an undercoat of paint that appears through a top layer, due to a loss of opacity that may occur after a long period of time.

Pilaster—a column attached to a wall.

Plein-air—illumination such as is found out of doors.

Quoin—external, solid corner of a wall.

Rustication—rough-hewn stone masonry used for facades in pre- and early Renaissance buildings.

Scumble—a semitransparent light color painted on a dark underpainting.

Stringcourse—horizontal course of stone dividing the stories.

Tempera—paint consisting of pigment dispersed in an emulsion (such as egg and water).

Tympanum—semicircular space above a door or window.

Other Books by Frederic Taubes

The Mastery of Alla Prima Painting
The Human Body—Aspects of Pictorial Anatomy
The Painter's Dictionary of Methods and Materials
Painting Techniques, Ancient and Modern
The Quickest Way to Paint Well
Better Frames for your Pictures
The Mastery of Oil Painting
The Technique and Art of Landscape Painting
The Technique of Oil Painting
You Don't Know What You Like
Studio Secrets
Oil Painting for the Beginner
The Amateur Painter's Handbook
The Painter's Question and Answer Book
Anatomy of Genius
Pictorial Composition and the Art of Drawing
Taubes' Painting and Essays on Art
New Essays on Art
Oil Painting and Tempera
Pen and Ink Drawing, I.
Pen and Ink Drawing, II.
The Technique of Portrait Painting
The Technique of Still Life Painting
Modern Art Sweet and Sour
The Technique of Landscape Painting
New Techniques in Painting
Abracadabra and Modern Art
Restoring and Preserving Antiques
Antiquing for the Amateur
The Mastery of Color